MEHNDI

ST. MARTIN'S GRIFFIN NEW YORK

MEHNDI

THE TIMELESS ART OF HENNA PAINTING

LORETTA ROOME

Production Editor: David Stanford Burr

Illustration on page 33 by Stephanie Rudloe
Designs from Marrakech, on page 36, courtesy of Mohamed Elmaaroul.
Designs from Bombay, on page 48, courtesy of Carolyn Barlow.

www.stmartins.com

Library of Congress Cataloging-in-Publication Data

Roome, Loretta.
 Mehndi : the timeless art of henna painting / Loretta Roome.
 p. cm.
 Includes bibliographical references.
 ISBN-13: 978-0-312-18743-9
 ISBN-10: 0-312-18743-2
 1. Body painting. 2. Henna—Folklore. I. Title.
GT2343.R66 1998 98-3362
391.6—dc21 CIP

10 9

What I tell you is not a secret.
The secret is in you.

FA-YEN

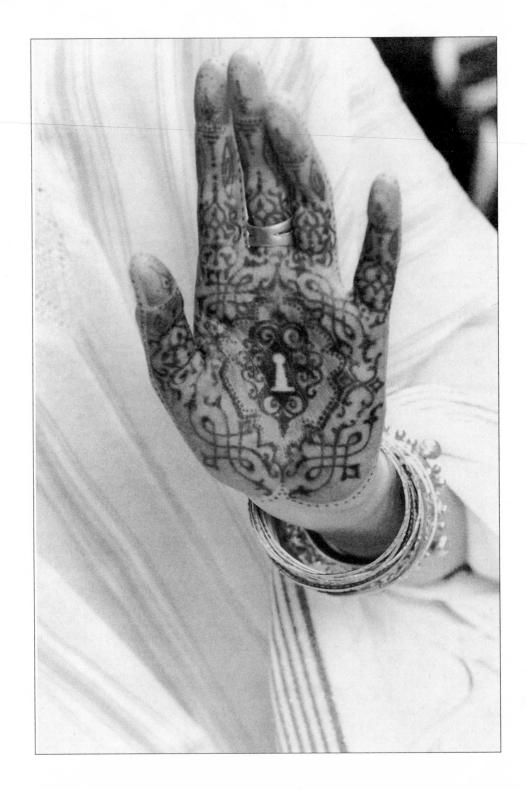

CONTENTS

ACKNOWLEDGMENTS

This book is the result of the talents and efforts of many people, and several years of hard work. I would like to thank all of the artists who generously gave of their time and expertise, sharing recipes and techniques, and letting their work be photographed for this book. Many of these artists are a part of the Mehndi Project, and I consider it a great privilege to be working side by side with them. I would also like to thank my first teacher, Rani Patel, with whom I had hoped to be writing this book.

The Mehndi Project began in August, 1996 at the Bridges + Bodell Gallery thanks to the generosity and faith of gallery owner, Margaret Bodell and the eight gifted photographers involved in this project from the start. During the month-long exhibition of photographs, hundreds of people of all ages and nationalities came to be painted and to learn more about how it is done. I would like to thank all of the people who helped to bring this project forward and give henna painting a new home in the West.

The Mehndi Project started a wave of international attention that made focusing on writing seem nearly impossible, due to the constant demands on my time. Without the help of Eric Feinstein, Tracey Eller, and Stephanie Rudloe, I would not have been able to do this book. I would also like to acknowledge the extraordinary support I received from the entire team at Witherspoon and Associates, especially Maria Massie, who was there for me at every turn. Their graciousness and professionalism have been truly inspiring. Many thanks to my editor, Marian Lizzi, whose patience, sensitivity, and diplomacy made every step of this process more pleasant and manageable.

I would like to thank the following people for their generous contributions which helped make this book a reality: Roy Kaufman, Mohamed Elmaarouf,

Sterling Rome, Nishit Patel, Paul Maher, Caro Barlow, Pamela Pollack, Henry Yee, Lucy Grealy, Jenny Dworkin, Ilene Staple, Jamila El Alaoui, Sangeeta Patel, Urvi Patel, Robert Tardio, Susan Lentini, Frank Ockenfels, Jill Waterman, Karl Steinbrenner, Audrey Davenport, Theo Coloumbe, Gordon Lange-Kelley, Jessica Shokrian, Judy Ann Olson, Huggie Foote, Carlos Sanches, Michael Ackerman, Serena Jost, Vinnie Panizo, Sandra Rodger, Marilyn Cvitanic, Aziza Riad, Kim Lenart, and Leigh Brown.

I would also like to thank the following people: Judith Hooper, Denise Kerr, Stephen Silverman, Victoria Mercuri, Gay Young, Dawn Davis, Latif, Kozmat Mohamed, Brahim Fribgae, Ruth Taveras, Suesan Stovall, Carrie Ashby, Fiona Stevenson, Dunya, Cybele Kaufman, Meagan Gannett, Kris Dikeman, Nancy Matsumoto, Jenny Liu, Adelaida Gabiria, Mañuela Amzallag, Lynelle George, Therese Gambacorta, Linda Pastorino, Dina Emerson, Antoinette Rowe, Stephan Zaklin, Halima Taha, Nacer El Alaloui, Kathy Lutwak, Rick Mercuri, Ranuka Patel, Howard and Rosalind Feinstein, Jonathan Feinstein, Amadeo D'Amado, Hank Cochrane, Sumita Batra, Alison Rose Jefferson, Rick Becker, Rabeah Ghaffari, Randolyn and Angus McCullough, and to the folks at the Queens Council of the Arts, Park Slope Copy, Valerie's, Sordi's, Akbar, and Leon at the Paper Place, and most of all the Community Bookstore in Park Slope for providing me with coffee and silence.

INTRODUCTION

This book is intended to give the reader what I was looking for in bookstores and libraries when I first became fascinated with henna painting. There was so much I wanted to know. In the past two years I have heard many others ask the same questions that I had asked: Can I do it? How? Where can I have it done? Is it really good for me? Where does it come from, and what is it all about? Is it the same henna that people use in their hair?

Like everyone else, I was looking for basic information, and there was something oddly elusive about the entire subject. My first question quickly became: Why is it so hard to find out about this thing?

The attempt to answer this question has greatly affected my entire experience in researching this topic. The answer is complex and has to do with the following subjects: women, eroticism, mysticism, privacy, religion, sacred ritual and ceremony, matrimonial and romantic love, folklore, and superstition.

My long search for information about mehndi became as interesting as the art itself, and the reasons why it's NOT known are part of what must be explored if one is truly to grasp its significance.

In his book, *Art of Rajasthan*, written in 1951, Jogendra Saksena made a passionate appeal to the people of India to preserve this uncommon art

and protect it from extinction. He wrote: "For, unless a fact, which is obscure and shrouded in mystery is uncovered and explained clearly, it becomes difficult to convince [people] about its values and utility."

In this book, I'm handing over a great deal of what I've been able to find out. On the back of Saksena's book are many flattering comments and reviews. The one at the top was written by Dr. Stella Kramrisch more than twenty years ago and reads as follows:

> The hurried mechanized life of the present has little time for such ritual, visual celebrations. The practice of [mehndi] will not survive. However, the knowledge of its form should become as widespread as that of the great monuments of India. . . .

The practice of mehndi has survived. It is my hope that this book may play some small part in its timeless history.

MEHNDI

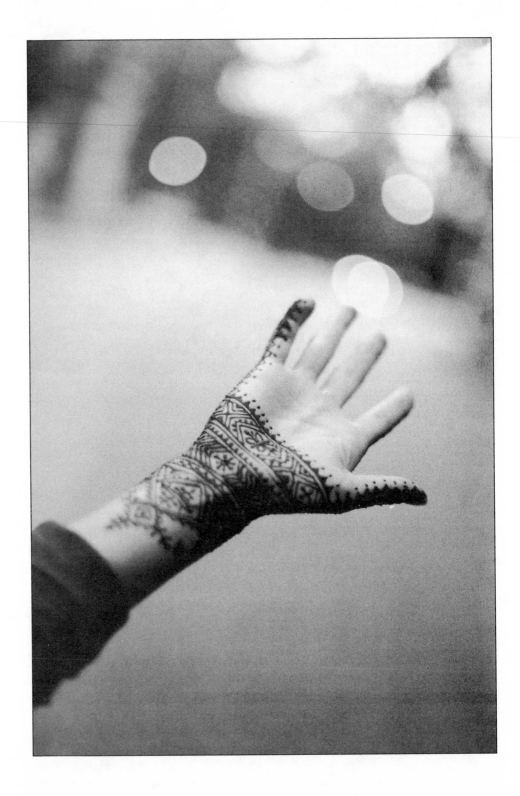

What Is Mehndi?

Mehndi is the word in Hindi used to describe henna, henna painting, and the resulting designs. Henna is a plant best known to us as a natural product used to color and condition the hair. Henna painting is an ancient cosmetic and healing art whereby the dried leaves of the henna plant are crushed into a powder, then made into a paste that is applied to the body to safely dye the skin. This is done in elaborate patterns and designs, traditionally on the hands and feet. The result is a kind of temporary tattoo, often reddish in color, which will last anywhere from several days to several weeks. The process is absolutely painless and in no way harmful to the skin. In fact, henna is said to condition the skin as it beautifies the body.

Mehndi is practiced in many parts of the world. From the deserts of North Africa to the villages of northern India, magnificent designs blossom and vanish upon the hands and feet of women as they have for thousands of years. Most commonly associated with romantic love and the ritual of marriage, henna designs are an integral part of bridal adornment in Hindu, Moslem, and Sephardic traditions.

Mehndi is an art form that traditionally has been practiced exclusively by women. In North Africa, Asia, the Middle East, or any Indian or Moslem community, you will find women who decorate themselves with henna. It is taught and practiced largely in the oral tradition, with recipes and patterns passed from one generation to the next. Henna designs may

be used in the East to celebrate a special occasion, much the way one in the West might bake a cake or a favorite holiday food. It's that natural and that integral. But while mehndi retains an aura of festivity and well-being, it remains a sacred practice intended not just to beautify the body but to invite grace and good fortune into one's home, one's marriage, and one's family. It is a kind of talisman, a blessing upon the skin.

Henna painting in its purest form is largely improvisational and intuitive. Ancient symbols and motifs are subject to the whim and imagination of the artist, and great emphasis is put on the singularity and originality of each interpretation.

This art has always involved a marriage of the personal and the traditional, spreading slowly from one culture to another over thousands of years and taking on new meaning with each incarnation. Now we become a part of this evolution by discovering for ourselves what mehndi means today.

THE HENNA PLANT

Henna is the Persian name, now used in many languages, for a small flowering shrub (*Lawsonia inermis*) originally found in Australia and Asia and along the Mediterranean coasts of Africa. Also known as the mignonette tree or the Egyptian privet, it is grown as an ornamental in subtropical regions of the United States and has been naturalized in many countries throughout the world. The plant grows eight to ten feet high and is often found in India as a hedge surrounding gardens, yards, or homes. The flower of the henna plant is small, white, four petaled, and sweet smelling. Although henna grows in a tropical climate, it does well in greenhouses and is therefore available elsewhere.

There are many different kinds of henna plants. In northern India, there are two major varieties of henna. One has very large leaves and is

known as *hina menhadi* or *menhada.* The other kind, known as *rajani,* has smaller, more fragrant leaves and is said to give a much brighter color.

Because there are so many dialects in India, there are also many words other than *mehndi* used to denote henna: *menhadi, mehendi, mehedi, mendi,* and in Sanskrit *mendika,* to name just a few.

THE MANY USES OF HENNA

Most people in the West know of henna because it is often used here to color hair. But in India and North Africa henna is of ancient repute for its medicinal properties and has long served many other functions. Used as an antiseptic and as an astringent, it is often applied to bruises and sprains, as well as boils, burns, and open wounds. It is used to treat ringworm and headaches, sweaty hands, burning feet, and athlete's foot. Because of the cooling effect it has on the skin, a ball of henna paste is placed in the hand of a fevered child in order to bring the temperature down. An extract derived from putting henna leaves in boiling water is used as a gargle to heal a sore throat, and taken internally to act as a tonic and to relieve stomach pains. The bark of the henna plant is used to treat jaundice, enlargement of the spleen, and various skin diseases.

As a cosmetic, henna is believed to condition and revitalize hair and skin and is often used to dye white hairs a darker color. It is said to kill lice and to prevent hair loss. It is also used as a deodorant, since its cooling effect prevents perspiration.

Aside from its cosmetic or medicinal functions, henna has long been used to dye leather and cloth, as well as the hooves and manes of horses. (One theory concerning the origins of mehndi in India links the arrival of henna with that of the Persian horses in the year 712.) Ceremonial markings with henna on walls, animals, and idols are also common.

Mehndi dates back to time immemorial. The practice is so ancient, with mythological origins in so many cultures, that where and when it actually began is difficult to determine.

The earliest evidence of the cosmetic use of henna is from ancient Egypt. It was common practice among the Egyptians to dye their fingernails a reddish hue with henna, and it was considered ill-mannered not to do so. Traces of henna have been found on the hands of Egyptian mummies up to five thousand years old.

There is a great deal of evidence to suggest that the henna plant was a gift from Egypt to India. Mehndi has been practiced in India for many centuries, as can be seen in the cave paintings of Ajanta and Allora, wherein a reclining princess is surrounded by women who paint her hands and feet with elaborate henna designs.

Henna is also believed to have been a popular cosmetic among the Hebrews and is often considered to be the substance referred to as camphire in the Bible.

Moslems have also used henna for many centuries. The prophet Mohammed used henna to dye his beard — a fashion adopted by the caliphs. Although staining of hands and feet with henna is also popular among Moslem women, it may have only been adopted into their tradition during the Mogul Era, when thousands of Hindus converted to Islam. Perhaps it was the strong presence of Islamic tradition in the Middle East and in northern Africa that helped facilitate the spread of henna painting all the way to Morocco, where even today it is as much a part of cultural ritual and ceremony as it is in India.

There is no word for myth in the Indian vocabulary. The terms *divya-katha* (divine story) or *pura-katha* (ancient tale) are used interchangeably. There is no sharp division between the notions of myth and reality as there is in the West.

The role of henna painting in the divya-katha involves Lord Shiva, the god of destruction and the most powerful of the Hindu deities. According to the tale, his consort, Parvati, would decorate herself with henna in order to please him and win his favor. He responded to her charms and, being a very difficult husband to please, earned mehndi the association of irresistible sensual allure and marital prosperity. This may also be the rea-son that mehndi is thought to placate the gods and ingratiate the adorned woman, protecting her and her family from misfortune.

Mehndi is so much more than a dye upon the skin. Perhaps this myth is at the root of its history, as it reveals the true functions of mehndi: to entice, to protect and to celebrate. But why henna, even for the goddess Parvati?

Mohamed Elmarrouf, native to Morocco and an authority on its cul-ture and traditions, would often say, "This is a magical plant," and truly this is no exaggeration. Henna is a plant with transformative powers. With its tiny fragrant flowers and green leaves, imagine what a miracle it must have seemed to the ancients for these average-looking leaves to give forth a *red* dye (and so potent a dye at that) and to have healing and cool-ing properties as well. It's no wonder that henna is used to honor and bless one of the most miraculous of human transformations—the meta-morphosis of man and woman into husband and wife.

Despite the variety of cultures that practice the art of henna painting, its primary use in each one remains the same, and that is to decorate the hands and feet of the bride (and sometimes the groom) for the wedding ceremony.

One theory regarding the origin of henna painting as a ritual practice links it to the defloration of the bride and the appearance of hymeneal blood. This connection becomes less abstract when one considers the color of the henna and the duration of its stain in relation to the menstrual cycle. Another link can be found in the poetry and folklore of India, where mehndi is often referred to as love juice.

Mehndi marks a *samskara*, or rite of passage, in a woman's life. In classical Indian tradition, there is no formal ceremony at the time of puberty to celebrate the young girl's coming of age. This time usually coincides with the celebration of marriage. Mehndi is therefore associated with the sexual initiation into womanhood, as well as the union of husband and wife.

The essence of this ritual is transformation. The girl who becomes a bride stands at the threshold of another existence. The joining together of the man and the woman in wedlock "encapsulates the creative activity which spawned the universe," as Richard Kurin points out in *Aditi, The Living Arts of India*. When a girl is initiated into womanhood through marriage, the realm of the sexual unfolds before her, as does the medium of henna painting. Like lovemaking, this becomes part of her vocabulary of expression. It will be shared at every celebration or festivity. She will explore it for the rest of her life, unless she is widowed, in which case she will usually abandon the art.

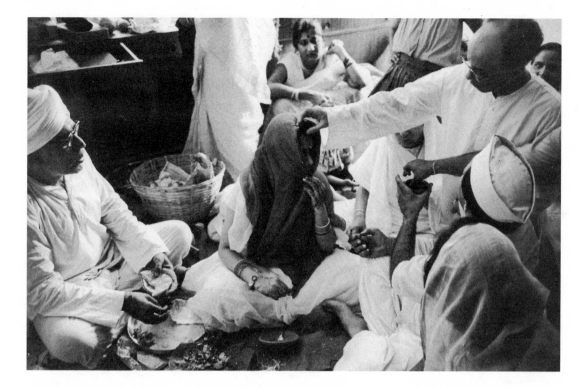

THE ART OF MEHNDI

In order to understand the art of mehndi, it is important to understand the role of bodily adornment in the places where this art form is practiced. For at least five thousand years, the people of India have devoted inexhaustible creativity and energy to the invention of ornamentation and designs that celebrate the human form through the medium of adornment. This is a spiritual endeavor, and in the words of author Oppi Untract, "By adorning the visible, material body, they also seek to satisfy a universal longing for the embellishment of its intangible counterpart: the human spirit."

In India, there is a special term *(shringar)* that is used to describe the beauty of a woman's creativity. The concept of shringar is a particularly

Marriage, for a girl, is a second birth, for in the patrilineal communities of India, she is known by her husband's name, joins his clan, and lives with his family. Marital preparations symbolize this new state by transforming the appearance, primarily of the bride, but also of the groom. This is done through ritual baths, changing of the clothes, and bodily adornment.

—JOGENDRA SAKSENA,
FROM *ART OF RAJASTHAN*

lovely one. A woman displays her shringar in the act of creative expression. She may do it with a gesture or in a great work of art. She may reveal it in the way that she adorns herself or another. Shringar is the power of beauty beneath the surface, and mehndi is one of the many ways that such beauty is made manifest.

The *Solah Sringar* mentions mehndi as one of the sixteen adornments of a woman, though mehndi is also included in the *Kama Sutra* as one of the sixty-four arts for women.

Adornment in India is usually motivated by religious beliefs and has none of the stigma of vanity and materialism that it has in the West. It is associated with transformation and transcendence. Ceremonial painting is considered sacred work, and beautification a form of worship.

THE INVISIBLE AND THE UNSPOKEN

Mehndi is a language. It is not just a beautiful art form. It asks the woman to have a dialogue with the universe, and it provides the words by which to have that dialogue.

In Morocco, animism—the belief that all objects and living beings possess a soul—figures greatly in the practice of any and every craft and art form. Beyond this notion of soul is the idea that certain objects and animals contain mystical power and positive energy. These magical properties are referred to as *baraka.*

The concept of baraka is key in attempting to understand the role of henna painting in Moroccan society. Belief in the existence of baraka makes every moment and mundane task an opportunity for spiritual meditation. Simple acts of day-to-day life—cooking, weaving, or cleaning—become a form of worship, prayer, or what some might consider magic.

All things contain baraka, but in varying degrees. The henna plant was said to be the prophet Mohammed's favorite flower and as a result is believed to have much baraka. It is therefore respected as part of Islamic tradition and is used by the Moslem people for blessings, protection, and purification.

Similarly, the Hindus believe that Lakshmi, the goddess of prosperity, dwells in henna designs. A Hindu woman will paint her hands with henna to feel Lakshmi's presence and earn her favor, but this can happen only if she is worthy. If the woman is not worthy or shows no respect for the customs that she has learned, it is taken as an affront to the goddess, and is thought to have serious consequences.

HENNA AS ORACLE

The tradition of henna painting is supported as much by superstition as by celebration. In the words of André Malraux, "All art is a revolt against man's fate," and for centuries women have tried to predict and influence their futures through the medium of mehndi. The very word *mehndi* orig-inally meant religious guide.

One of the most common superstitions about mehndi has to do with the color of the henna on a bride's hands. If the color is deep and red, it is said that the love between the husband and wife will be strong and long-lasting. Henna is often the first gift from the bridegroom to the bride, and it is therefore thought that the color speaks of the love he will feel for her.

There are many ways in which men and women use henna as an ora-cle. Sometimes a dot of henna will be put on the forehead to determine the fortune of the man or woman: if it stains, it is thought to signal good luck.

Although henna's use as a divining vehicle is not to be minimized, its more popular function is the attempt to influence the events of the future.

Women in every country practicing henna painting offer their designs to the spirits, gods, or goddesses in an effort to appease them and win their favor.

In Morocco there is a very clear understanding that symbols of protection are "the only action a human can take in the face of *mektoub* (destiny), the determining force behind every individual's life." Often henna is used to guard against misfortune. It is used for its magical powers and in some ways is practiced in the spirit of witchcraft. Different patterns and depths of color of the henna are thought to please the various spirits (*djoun* or *djun*). A woman will often have a henna party in order to placate a spirit or to make a particular request. For instance, if her child is sick, she might promise to have a henna party to honor a particular spirit who she believes could answer her needs and heal her child. Whatever the nature of her request, if she fails to follow through with her promise, it is believed that great misfortune could befall her.

Such practices may be dismissed as purely superstitious by the nonbeliever, though perhaps it would be wise to consider their deeper significance. After all, despite the great advances of technology and all the comfort and protection it affords us, man still remains defenseless before the whim of fate. Ultimately, we know nothing more than our prehistoric ancestors about why we are alive on this planet, and though we effectively distract ourselves from the inevitability of death, our lives lead us forward into the unknown.

Contemplating mehndi's traditions may help deepen an awareness of

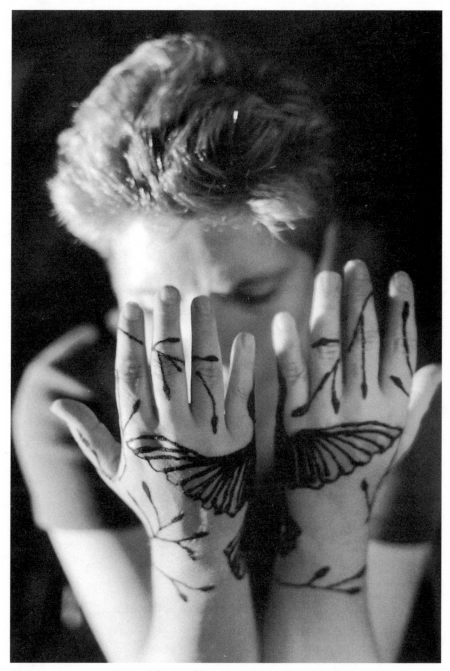

Spell became poetry and magical [painting] became art. The spells are the "lyric cry of soul" . . .
reflections of delicate desires of the mind. . . .

<div align="right">

—JOGENDRA SAKSENA,
FROM *ART OF RAJASTHAN*

</div>

our relationship to life's fundamental mysteries. The traditional use of henna is similar to prayer, and, whether it reveals a regret, a request, a fear, or a superstition, it admits to the presence of forces beyond our comprehension—forces infinitely greater than ourselves.

Mehndi Designs
and What They Mean

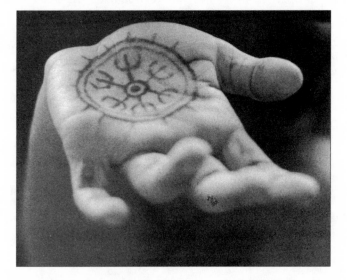

*However different the personal styles may be in which man
expresses himself and addresses himself to the ultimate being,
there are symbols which are shared, and a common store of
symbols always will remain. Are there not languages which
despite all differences have the same alphabet in common?*

—VICTOR FRANKL

Mehndi is a secret language—a language of symbol. Though meanings of
specific signs and patterns may vary from culture to culture or even from
person to person, the use of symbols is universal. Symbols are the lan-
guage of the unconscious and of the ancients.

A person in India embraces the idea of a powerful, mystical meaning

behind the act of adornment. A woman in Morocco decorates her body in keeping with her spiritual faith.

Symbol occurs in mehndi on many different levels. There is the symbolism of substance and action, as well as that of the actual designs.

As mentioned in Chapter One, the henna plant is a symbol of transformation, celebrated for its usefulness as well as its decorative potential. (Its healing properties make even more poignant the brief life span of each intricate and beautiful design.) There is the symbolism of the act of painting with henna, the metaphorical significance of the plant itself, and finally, there is the symbolism of the designs themselves. These multiple levels of metaphorical meaning make mehndi a highly charged and extremely potent medium of expression.

It is essential in the study of henna painting to acknowledge the true nature of the art, which was based not on vanity, habit, or superstition, but on reverence, ritual, and prayer. We can never know for certain what significance the symbols in these designs held for women of the past, but with the help of such scholars as Joseph Campbell and Carl Jung, we can glimpse the timeless nature of their universal meaning.

THE MIRACLE OF SYMBOL

The realm of symbols is profound and multidimensional. The deeper one's exploration of the symbols used in henna painting, the harder it is to distinguish between the beauty of science, the power of art and religion, and the miracle of the human unconscious. Many of the symbols used in henna painting have existed for centuries and predate the scientific and mathematical studies that give new meaning and significance to their use.

Learning about these forms is like discovering a hidden universe.

How is it that a sacred symbol of the life force would later be discovered to be the exact shape of the hemoglobin in the blood? That magnificent mandalas like those seen in the stained-glass windows of a cathedral or in the sacred mosaic patterns in a mosque would later appear and metamorphosize endlessly in one of the greatest scientific discoveries of the computer age: fractal geometry and the Mandelbrot Set, a formula that is infinite and reveals an everchanging, neverending universe of possibility?

In his book, *The Art of Rajasthan,* Indian scholar Jogendra Saksena writes of the magical nature of this art form. Although he wrote his book in the 1950s and made no mention of the work of Carl Jung, it was quite a relief to discover that he was equally astounded by the correlation between the symbols of these designs and natural phenomena revealed through scientific discovery. With his knowledge of subjects like tantra and meditation, he was fascinated by the intuitive powers of the human mind revealed through ritualistic and spiritual art.

The symbols used in mehndi are often similar to the tantric designs *(yantras)* used by yogis in their meditative practice. Tantric designs were used as mediums of transcendence. By practicing *sadhana,* defined as the mental training necessary in spiritual endeavor, the yogi, by focusing on the yantra, is believed to achieve communication with the deity ruling each particular design.

Saksena believed that the men who were able to do this were masters of intuition, using "mystic powers which could penetrate through space, time and matter."

I like to think that the beauty of symbol and equation hidden in nature is no secret to the deepest part of our being, and that we have only to catch up to the miracle we are so much a part of.

In this chapter, I will focus on the two parts of the world most known for their traditions of henna painting: Morocco, the westernmost tip of North Africa, and Rajasthan, a region in northern India. The sym-

bols used in the designs from these countries date back centuries and provide the most vital link between contemporary and ancient practices.

Traditional Indian Symbols

BASIC FORMS

According to tantric philosophy, a *bindu* (point) is the Supreme Reality. It is the mysterious matrix, the *bija* (kernel or seed) from which everything emanates and in which everything merges.

All symbols begin with the bija. Beyond it are the simple geometric forms we take for granted, which together create an alphabet for mehndi's secret language.

There is the line *(rekha)*, and then the angle *(kona)*, which occurs with the joining of two straight lines, thereby reflecting the duality of life.

One of the most powerful Indian symbols is the triangle *(trikona)*. Pointing up like a mountain, it signifies the active male principle *(purusa)*. Reversed, it is the passive female principle *(prakriti)*. Resting on its base, it represents fire and the ascent to heaven and is attributed to Shiva. Reversed, it reflects all that is female—water, fertile valleys, and the grace descending from the heavens. It is attributed to Shakti. The triangle is also the symbol of the trinity of Brahma, Vishnu, and Rudra. Brahma is the god associated with the creative power, Vishnu with sustaining power, and Rudra, vedic god of storms, is connected to Shiva and the divine forces of change. In common practice, the triangle may also be used to represent everything from a water chestnut to a mountain range to a piece of cloth.

The *satkona*, or six-pointed star or hexagram (see Diagram 1), signifies the union of the feminine and masculine principles. Its association with

DIAGRAM 1

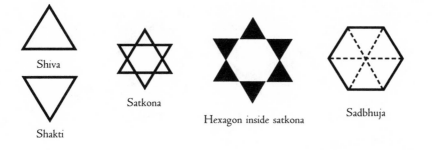

Shiva

Shakti

Satkona

Hexagon inside satkona

Sadbhuja

Lakshmi, the goddess of good fortune and prosperity, suggests that great success is the result of these two principles working in perfect harmony.

Look within the six-pointed star, and you will find the hexagon *(sadbhuja)*. The hexagon is a powerful form that nature employs profusely. In beehives, snowflakes, and turtle shells; in clusters of water bubbles (the shape is the result of closely packed circles); and in the cells of our own bodies, one finds echoes of the hexagon. The sadbhuja also appears in many forms of ritualistic painting.

Catuskona, the square, symbolizes stability and order, the earthly realm, and the balance of opposing forces. It implies honesty, shelter, and dependability. It is also called the *muladhar,* meaning the original base or the real foundation. It is the most common form in Hindu symbology.

The diamond *(vajra)* symbolizes enlightenment *(bodhi)*.

The pentagram, or five-pointed star, is called *pañcakona*. Its five sections symbolize the elements of fire, water, earth, air, and the heavens. This shape is associated with black magic and the occult.

The octagon *(astakona)* is created by two overlapping squares, just as the hexagon is two triangles (see Diagram 2). It is connected with Lord Vishnu, protector of mankind, moral order *(dharma)*, and the world. It is

DIAGRAM 2

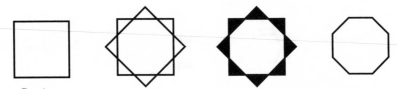

Catuskona

Astakona (octagon) formed by overlapping squares

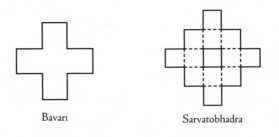

Divided octagon

Ashtadala

DIAGRAM 3

Bavari

Sarvatobhadra

The discoveries of science, the works of art are explorations . . .
explosions of a hidden likeness.

—J. BRONOWSKI,
QUOTED IN *THE DIVINE PROPORTION*

therefore used as a symbol of protection. When transformed into *ashtadala,* (eight petals), it becomes a symbol of the sun used in solar worship.

The cross *(bavari)* symbolizes a reservoir or well. When a square is superimposed on it, the resulting design is called the *sarvatobhadra* (Diagram 3). This is a very auspicious symbol. It is a mystical form in which the square represents a temple or sacred space, and the cross forms entrances on all sides. This compelling symbol, which also appears in African henna designs, strongly resembles the

This ancient Indian symbol of the circle and the cross may be derived from a similar composition discovered on fragments of pottery in Syria and Iraq, dating back to the sixth millennium B.C.

microscopic structure of porphyrin, which is common to both hemoglobin (an essential component of blood that helps the body assimilate oxygen) and chlorophyll (necessary to photosynthesis in plants). This is a perfect example of the ways in which scientific discovery adds a profound dimension to the spiritual significance already attributed to these forms.

THE MANDALA

The circle *(cakra)* is whole, perfect, infinite, complete. It has no beginning and no end, only within and without. It is the most beautiful symbol I know. It is the self, or in the words of Carl Jung, the "totality of the psyche in all aspects," man in relation to the universe, the sun, the moon, the earth, the stars.

The circle is the shape of the planet upon which we live, and the eyes with which we see. The iris is a perfect mandala, concentric patterns of color surrounding the dark center of the pupil. Is it any surprise that the mandala is considered a symbol of enlightenment, when it exists within us as an organ of vision?

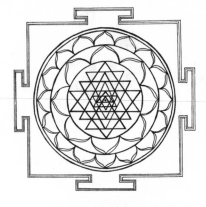

A mandala may often assume the shape of a circle, but it is actually based on the concept of concentric forms relating to a center point. Mandalas frequently contain circles, squares, and triangles, and reach their quintessential form in the yantras of ancient India. These, as mentioned earlier in this chapter, were used in spiritual practice as a meditative tool. In his book *The Secret Language of Symbol,* David Fontana writes that yantras "provide a more advanced focus for meditation because they represent the realities that lie beyond the world of physical forms." It is thought that by concentrating on these forms the viewer penetrates the many layers of reality and moves toward an inner truth.

THE LOTUS

The lotus is a mysterious and compelling symbol and my favorite representational image used in the art of mehndi. With its stem and roots vanishing into the murky waters and its blossoms opening skyward, it symbolizes the self emerging from unconscious depths—the awakening of the human soul, rising from the darkness of ignorance and seeking clarity and enlightenment. The lotus embodies the duality of nature, existing in two realms—above and beneath the visible surface. It is associated with grace, beauty, femininity, opportunity, and sensuality.

The lotus plays a central role in Hindu mythology. In art, it is a symbol connected to the goddess Lakshmi, and she is often featured standing on, surrounded by, or holding the flower. Once adopted into Buddhist iconography, the lotus became associated with purity, since neither leaves nor petals show any trace of the mud out of which they grow or the

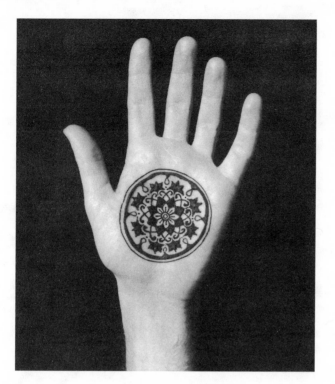

water upon which they rest. Beyond this, the lotus represents all plant life and the bounty and abundance of the earth. It is also a symbol of creativity, consummation, and the female sexual organ, as well as the tree of life.

The lotus appears in many forms and is sometimes difficult to identify. It can appear in the form of a single bud or have any number of petals. Though usually depicted as pointed, the petals of a lotus may often appear rounded as well.

Lotus rosettes are often eight-petaled, with outer layers increasing in multiples of four. The thousand-petaled lotus *(sahasrara)* is a symbol of attainment, uniting the soul *(atma)* with the Almighty God *(Pramatma)*.

In mehndi, the lotus may take the form of a mandala, a flower floating on a horizontal plane, or even the fictional form of a creeping vine. There is no right or wrong way to depict this symbol of the soul seeking light.

DIAGRAM 5

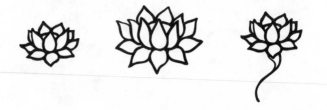

Lotuses

The Lotus is certainly the most remarkable symbol of India. . . . It is clear that the lotus is
undoubtedly a symbol (among other things) of the female sex organ (yoni). It was from the
cosmic lotus that this world, including the gods, was created, and future worlds will have the
same origin. Invariably female beauty (and sometimes male as well) is described in Indian
literature by analogy with the lotus.

—JOHN W. SPELLMAN,
FROM THE INTRODUCTION TO
THE KAMA SUTRA OF VATSAYANA

Long before I knew the significance of the lotus, I drew it in my
hand, hidden within two folding wings. From the center of the open
flower rose a second flower, a tiny bud. It was a time when my desire for
solitude forced me to retreat from the outside world. I knew the flower
was my self in need of privacy and protection, but most moving to me
was the bud—the hope and ever-present potential for renewal.

OTHER SYMBOLS IN MEHNDI

Motifs common in the practice of mehndi include the sun, the moon, and
the stars—all symbols of deep and lasting love between the husband and
wife. Other patterns include flowers, sweets, games and game boards, vines,
waves, scorpions, peacocks, parrots, pickles, people, sweetmeats, earthenware
pots, pitchers, musical instruments, elephants, fans, feathers, fabric, and

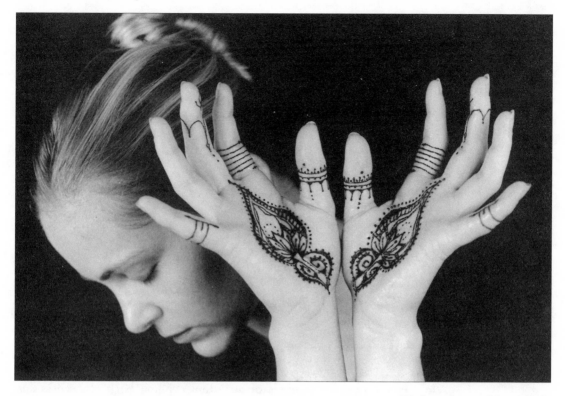

flames. Each of these items has a significance and meaning relative to its role in the life of the individual and the community.

Fruits, Flowers, and Vines:

Flowers are believed to be joyful symbols, and many kinds aside from the lotus are frequently used. These include sunflowers, water lilies, daisies, lilies of the valley, irises, and roses, to name a few. Roses are a common bridal motif, as is the unripe mango *(keri),* a symbol of virginity and of the advent of summer.

The lotus, then, symbolizes both the sun as the heart of space and the heart as the sun of the body, both moved by the same indwelling self. And accordingly, the lotus open to the sun symbolizes the fully flowered knowledge of this mirrored truth, while lotuses in bud mark stages of approach to its recognition.

—JOSEPH CAMPBELL

Mangos:

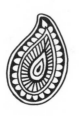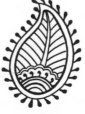

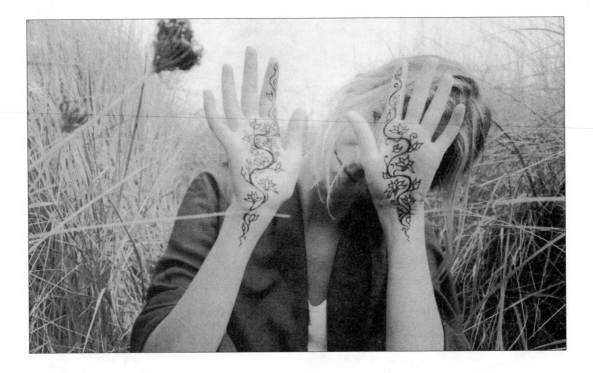

Vines or creepers are symbols of devotion, evoking both tenderness and vitality. The fact that they grow constantly toward the light and require support for their ascent suggests dedication, perserverence, and the basic needs shared by all living things. In Hindu mythology, a fantastic creeper known as the *kalpalata* is said to create a link between the gods and all earthly inhabitants. The spirit of the kalpalata is thought to reward reverence by granting the wish of the believer.

Animal Motifs:

The most commonly seen animals in the mehndi designs of India are birds, and the most commonly seen bird in these designs is the peacock *(mayura)*. The peacock is indigenous to Asia and is the national bird of India. Known for its beauty and magnificent plumage, the peacock is considered the companion of a wife longing for her husband in periods of

separation. With their grace and beauty, these birds were thought to distract women from their grief and preoccupy their attentions.

Other birds such as swans and parrots also appear in mehndi designs. The swan *(hamsa)* is a harbinger of success, whereas the parrot is depicted as the messenger, carrying secret messages between loved ones.

One of my favorite motifs is that of the fish, to symbolize the eyes of a woman. The scorpion *(bicchu)* is also a romantic symbol; its sting is analogous to Cupid's arrow.

Objects as Symbols:

Many objects of everyday life find their way into the mehndi designs of the Hindu woman. The fan *(bijani)* is a symbol of summer and of cool air bringing relief from the heat. It is therefore associated with tranquility, expressing the wish for peaceful interactions between husband and wife.

The pitcher *(kalasa)* is sometimes used as a symbol of domestic bliss. The kalasa is said to hold sacred water and, set high on the altar, it is present in all religious ceremonies. Its use as a vessel holding water for the divinity gives it the association of fullness and purity.

Water:

The motifs common in the rainy season use water as a symbol of human emotion. *Bundakis* are small dots clustered to give the feeling of falling rains. They are used to symbolize the love and affection a woman showers upon her husband and in-laws.

Also drawn during this season are *lahariya* designs, which are stylized impressions of waves or ripples. These patterns are associated with deep

*A scorpion has stung me, I am smitten,
oh my Lord!
My finger is splitting, my wrist is exploding,
oh my Lord!
This scorpion has stung me, its poison
is sending ripples in my body;
I am smitten, oh my Lord!*
—FROM "BICHŪRĀ" (A POPULAR FOLK
SONG OF RAJASTHAN)

passion and ecstasy and occupy a place of honor in all their many forms. The word *lahar* means a wave or ripple in water, but it is also used to describe the surging nature of human emotion, from longing and sorrow to joy.

Given the intensity of their significance, lahariya designs would often be the patterns worn by widows who chose to die with their husbands. Decorating themselves with mehndi and other finery, they would lay upon the funeral pyres, greeting their deaths in full bridal adornment.

PATTERNS AND STYLES

The use of pattern is key to the art of henna design. Patterns are made of symbols, just as symbols are made from patterns. Nevertheless, it is important to distinguish between the two because their functions in art are quite different. As a Western art student, I was taught a hierarchy of artistic endeavor, which placed an emphasis on "higher arts" (sculpture or painting) and looked down upon the "decorative arts" as crafts, not fine art. The "artisan" and the artist were worlds apart.

My work with henna has made me question these generalizations. Mehndi is a medium defined by pattern, and pattern suggests to me a humility absent from the singular image. Pattern allows an embellishment of the hand itself, whereas a solitary central image transforms the palm into a canvas and draws the focus of the viewer to the central image. In fact, this style is called New Mehndi and is influenced by the presentation of artwork in a gallery or museum setting. It involves the use of negative space around a central motif, much the way a white wall is used behind a painting. Although the representational image is sometimes used in mehndi, it is used minimally. It is quite common to see a hand or foot covered with decorative patterns, with no central motif. I

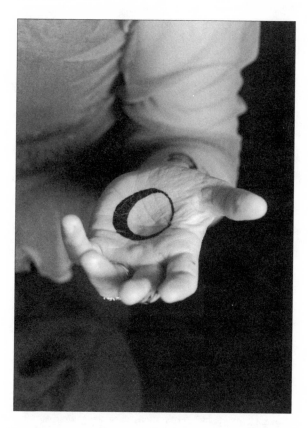

We live in a universe of patterns.

 *Every night the stars move in circles across the sky. The seasons cycle at yearly intervals.
No two snowflakes are ever exactly the same, but they all have six-fold symmetry. Tigers and zebras
are covered in patterns of stripes, leopards and hyenas are covered in patterns of spots. Intricate trains
of waves march across the oceans; very similar trains of sand and dunes march across the desert.
Colored arcs of light adorn the sky in the form of rainbows, and a bright circular halo sometimes
surrounds the moon on winter nights. Spherical drops of water fall from clouds. . . .
We have discovered a secret: Nature's patterns are not just there to be admired, they are vital
clues to the rules that govern natural processes.*

<div align="right">

—IAN STEWART, FROM *NATURE'S NUMBERS*

</div>

have never seen a representational image without a pattern around it, as
is common with tattoos.

 In some cases, pattern is used to embellish the central motif and fur-
ther enhance its power. In other cases, it is meant to enhance the beauty

of the human form. Patterns can also be seen as a necklace of symbols, the way music is a series of tones.

The significance of these patterns is infinitely rich. After all, nature is composed of patterns. Aside from their stunning beauty and grace, these patterns contain vital clues to the systems and orders that govern the universe.

Just as patterns in decorative art reflect those in nature, so are the different styles of traditional henna painting greatly influenced by the geography of the places where it is practiced. The three primary styles of henna painting can be categorized according to a variety of landscapes: the geometric patterns of the mountainous regions, the floral patterns of the plains and fertile areas (and in some cases the deserts), and the floral-geometric patterns of those areas in between.

Patterns create different styles and result from different styles. In India, there are a number of ways to categorize styles of henna painting. Floral designs are associated with magical and socio-religious practices, whereas the more geometric forms have a tantric significance and a mystical energy synonymous with the various divinities they reflect.

Beyond this there are further classifications according to season, ceremonial use, and various festivals. Of course, there is also a distinct difference between styles of painting done in different communities, as well as in different countries.

Geometric designs are most popular in urban Morocco. This may be due, in part, to the Moslem faith, which prohibits the representation of animals or humans in art.

There are many Moslems in India and in many other Eastern countries as well, but Islam is the governing faith of all of North Africa. It is considered blasphemous in this tradition to attempt to duplicate the work of God. Instead, the decorative arts are thought to provide a medium of praise to celebrate God's glory.

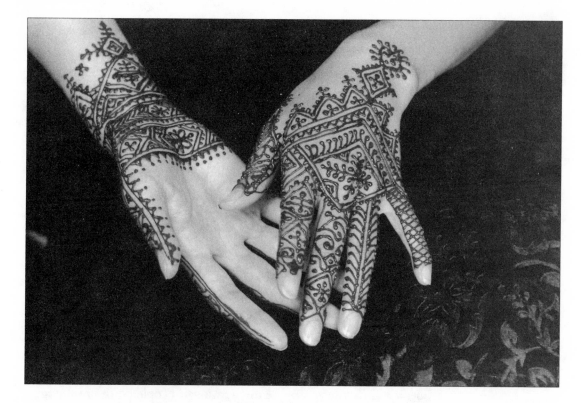

Nevertheless, representational images are common, especially among rural artists. Many of the symbols found in the henna designs, textiles, and crafts of Morocco predate Islam and are derived from ancient tribal customs and beliefs.

The Berber people, for instance, who were among the earliest known inhabitants of Morocco, live much the way they did centuries ago. Although they have adopted the Moslem faith, they retain many of their own traditions and customs, which accounts for their animistic beliefs and mystical practices. The art of concealment became an extremely important part of the use of symbols forbidden by Islam. This is why many of the Berber representations of animals consist of simple geometric shapes (see page 34).

In this modern age values have changed and designs are reduced to decorative elements, but they were once created by people who believed in phenomena outside rational thinking and attempted to master the "unreal" part of their existence with such symbols.
—H. REINISCH AND W. STANZER, FROM *BERBER*

The Symbols of Morocco

A woman in Morocco is not generally concerned with the origins of symbols. She is interested instead in their effectiveness and magical properties: She wants to know which ones work.

The symbols of Moroccan culture involve two primary concerns: fertility and protection. Symbols of protection are featured most prominently in all aspects of life and art.

Much power is attributed to the eye and the hand in Moroccan culture—the power to protect and the power to do harm. This is why the evil eye is still feared by many throughout the Mediterranean world. Belief in the evil eye is more than the fear of a hateful stare full of malintent; it involves a belief in the powers of an unloving glance to bring bad luck to the person upon whom it falls. Used as an explanation for just about every kind of misfortune, it is often considered the result of covetousness, and its effects may be unintentional. People go to great lengths to protect themselves from negative intention with images of *el ain*, the eye, which is thought to mirror back the evil eye, and *khamsa*, the hand, which symbolizes human creativity and power. These motifs exist in many forms: abstract, stylized, or realistic. They are the most commonly used symbols in all of Morocco, displayed in henna, amulets, ornaments, and textiles.

EL AIN

The defensive eye appears in many forms in the ritualistic and utilitarian arts of Morocco. Triangles, diamonds, circles, dots, "lozenges," and crosses are all used to symbolize the eye (see Diagram 6).

DIAGRAM 6

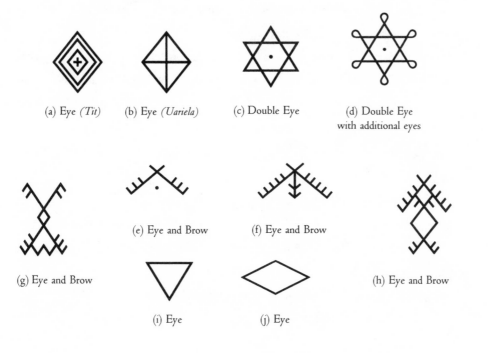

(a) Eye *(Tit)* (b) Eye *(Uariela)* (c) Double Eye (d) Double Eye
with additional eyes

(e) Eye and Brow (f) Eye and Brow

(g) Eye and Brow (h) Eye and Brow

(i) Eye (j) Eye

One of the most popular Berber motifs used to deflect the evil eye is that of a cross at the center of two or more diamonds (Diagram 6a).

The shape of the diamond is referred to by the women of Beni Mguild as *timrit*, meaning mirror, perhaps suggesting the idea of reflecting the evil eye. A diamond within another diamond is called *tit*, meaning eye. The symbol of the cross in the center is commonly mistaken for a Christian image, but is, in actuality, an ancient Berber symbol. The cross is believed to direct the energy away from the center point, in four different directions: "to disperse to the four winds the evil emanating from the eye" (Susan Searight, 1984).

31

A similar symbol of a cross within a diamond (Diagram 6b) is known as *uariela* or *uarida*, which means the center of a round thing, leaving researchers to speculate as to whether a diamond may double as a circle in the iconography of the Berber people.

Permanent tattooing is a tradition still prevalent in rural Morocco, though it is frowned upon by Islam. These are countless variations of symbols for the eye in this medium (Diagram 6c–j). Occasionally these find their way into other mediums, like henna painting, though they are quite distinct in their style and usually distinguished by the accompanying eyebrow.

The significance of basic shapes like the dot or triangle changes according to the number of shapes used in a particular sequence. For example, one triangle would signify an eye, but five would signify a hand. A single square may be thought to have healing powers, whereas squares joined at the corner become a symbol of protection (Diagram 7).

DIAGRAM 7

Amulet

THE NUMBER FIVE

Clearly, the importance of numerology in Arabic culture has influenced symbolism in the folk arts. To attribute magical power to numbers is in essence no different than assigning it to various shapes and forms. Numbers are symbols, after all—shapes signifying quantities.

Specific numbers are assigned magical powers in Arabic tradition. Odd numbers between 1 and 10 (3, 5, 7, 9) and their multiples are believed to have these properties. This, of course, greatly affects the realm of pattern and form in the ritual arts. (For instance, the magic square is a design used to heal and protect the sick. It is composed of numbers whose sum is the same whether added up horizontally, vertically, or diagonally.)

The significance of the number five in Moroccan culture is very specific. To wear or possess any manifestation of this number or any symbol of the human hand is thought to have the protective power of reciting the words *khamsa fi ainek* (five in your eye), or effectively poking one's fingers into the evil eye. The mere mention of the word *five* in the presence of another may be interpreted as an accusation and therefore an insult.

Any combination of five elements—triangles, dots, diamonds, crosses, stars, or other markings—is reflective of the *khamsa*, the protective hand of the prophet Mohammed's daughter Fatima (see Diagram 8). According to myth, Fatima was the first woman to use henna to decorate her hands. Perhaps this is why the less abstract depictions of the hand often seen in Moroccan jewelry and ornament are frequently decorated with intricate patterns and designs (Diagram 8a).

DIAGRAM 8

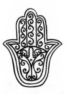

a. hand (khamsa)

b

c

other hands

d

e

f

g. finger

DIAGRAM 9

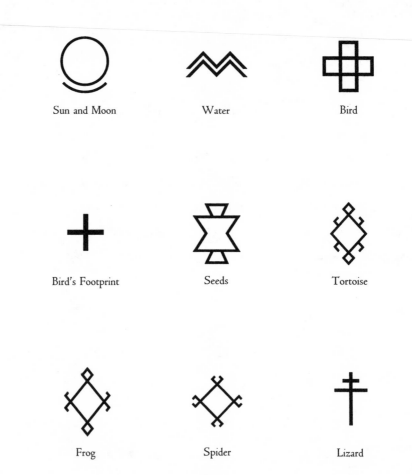

Sun and Moon Water Bird

Bird's Footprint Seeds Tortoise

Frog Spider Lizard

There is little doubt that the artistic vocabulary used by both the rural and urban artisan today in Morocco has changed over the course of the country's history. Many symbols, motifs, and tattoos have disappeared altogether from use, or had their meanings transformed over time. There remains, however, a repertoire of designs that have been utilized by artisans for many centuries. This includes magic numbers, magic squares, verses of the Koran, the Arabic script, geometric figures (triangles, squares, crosses, eight-pointed stars, Stars of David, spirals, circles, and diamonds), floral and other vegetative motifs, abstract and representational animal designs, human hands and eyes, and a vast array of tattoos.

—JAMES JEREB

OTHER SYMBOLS AND FORMS

There are many other beautiful symbols present in the rural artistic tra-
ditions of Morocco, but they are given much less emphasis due to the re-
strictions imposed by Islamic practice. As mentioned earlier, this resulted
in the depiction of representational imagery through simple geometric
forms. These include symbols of the elemental forces of nature, seeds, an-
imals, and animal parts.

Images of fierce animals like the snake, scorpion, or jackal, instead of
inspiring fear in the wearer, are seen as symbolic protectors. The snake
may appear in realistic or abstract form and is associated with the phallus;
consequently, it is a symbol of the libido and fertility.

Of all the animal symbols in Morocco, the scorpion seems to appear in
henna painting with the most frequency and the least discretion.
Surprisingly, it is depicted in a very realistic manner. It is used as a symbol
of protection, as opposed to its function as a romantic symbol in India.

The fish is associated with water and rain, making it a symbol of the
earth's fertility and abundance. The turtle is associated with the saints
and therefore used as a symbol of protection, though it too is considered
a fertility symbol because of its relationship to water.

Just as in Hindu tradition, the bird is described as a messenger—
although, according to the Koran, it is a messenger between heaven and
earth. The eagle, on the other hand, is a symbol of power.

Lizards and salamanders are baskers—sun-seeking creatures once revered
by the ancient sun cults. They symbolize the soul's search for enlighten-
ment.

Although there are many abstract motifs one sees again and again in
Moroccan henna, trying to ascertain their meanings is a challenging task.
The reason is the complex nature of mysticism and religious belief in this
country, as well as the impact of modernization.

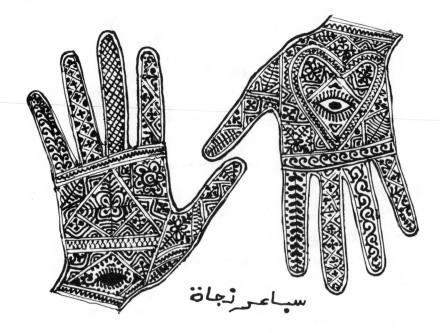

سبا عر نجاة

Despite a general accord in the
description of common motifs,
the esoteric background knowledge
of these signs is increasingly
disappearing because of sociological
changes . . .

—H. REINISCH
AND W. STANZER

H. Reinish and W. Stanzer point out in their book, *Berber*, that henna artists, like many other women, follow a "secret collective female code by adhering to systems of ceremonies, customs and conventions" associated with the folk arts. However, they also add that "there are few old women left who are consciously able to include religious themes in their artistic concept."

A VANISHING PERSPECTIVE

Despite the fact that mehndi offers a window through which we are permitted to glimpse a hidden world, it has long been ignored as an art form and a field of study. Mehndi offers a rare anthropological opportunity for East and West alike.

In *The Art of Rajasthan*, Jogendra Saksena writes that "folk-art is an ex-

pression of community consciousness," and in these countries, where the feminine voice has been so painfully ignored and a woman's perspective given so little attention, it is shameful to no longer take notice of this conspicuous omission.

The lack of acknowledgment and awareness of women's art in these countries has taken its toll on the medium. The majority of symbols used in henna painting are ancient in origin. Sadly, much of the meaning behind the use of these symbols has been forgotten and lost. The pace of life in the computer age has many of us going through the motions of things without necessarily understanding their significance or purpose. Members of urban societies, even in India and Morocco, are less attuned than their rural ancestors to the metaphorical properties of henna painting and are more apt to perceive it as a purely cosmetic or decorative medium.

What I have learned in talking to many women from India and the Middle East is that mehndi is often looked down upon by women eager to become "modern" and successful. Adjectives like *old-fashioned* and *peasant* are used to describe the practice. It is associated with primitive beliefs and rituals. The pressure to keep pace with the changing times has caused many women to turn away from the tradition altogether.

Equally distressing is the fact that many of the women still practicing the art help to contribute to the misunderstanding surrounding it. Many do not acknowledge the significance of the patterns and designs that they themselves use. It is not uncommon to hear a woman who has been doing henna all her life tell you that a specific traditional design has no particular meaning. This is just not true. It was very confusing for me when I first began my research.

In conducting a study in India in the late 1940s, Saksena noted the increasing lack of awareness, writing:

I was surprised to find that the women are just keeping the tradition alive, but they do not have anything to explain. In this way, the spirit of the art, which had been its life force and fountainhead is now getting dried up. Women whether in urban or rural areas, on the other hand, are getting too busy to think of this art. They try to acquire it quickly and superficially without caring to learn it properly.

He goes on to say:

The various lines and dots put together to compose a design tell a lot about it. But women today are forgetting all these details about a design. It is, perhaps, because they do not believe that the designs drawn by them have any purpose or motive besides what they understand, that is, they bring luck and prosperity to the household. For them it is a common phenomenon, which is neither of any significance in itself nor should it be viewed from that angle.

People have created many things that we use but cannot explain. How many of us really understand the science behind technology as it exists in our daily lives? But the dilemma of an ever-widening gap between what we experience in this modern world and what our all-too-crowded thoughts are able to grasp creates a dangerous invitation to surrender—to fall asleep and not trouble ourselves to know about our world.

It is said that a plague of termites once threatened to wipe the henna plant out of existence. The pressures of modern life pose a similar threat, for while "tradition" is preserved in ritual activity, it does protect the individual from the dangers of losing touch with his or her creative spirit. Ritual can become habit, remaining intact, while meaning erodes from beneath it.

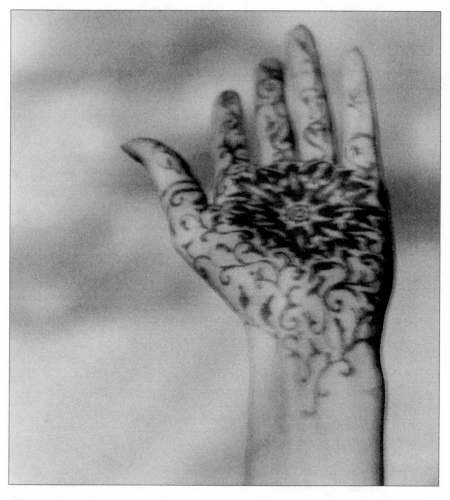

These motifs and their treatment uncover before us the essential truth that the art of designing whether ritualistic or utilitarian is not the proprietary of any age or any place, however remote in time and space they might have been. Nor are they the monopoly of any race or culture of any country, rather they reveal the working of a creative human mind, through the ages.

—JOGENDRA SAKSENA,
ART OF RAJASTHAN

Plato said, "The unexamined life is not worth living." Symbols are the language of the human soul; the language of our unconscious speaking to us in our thoughts and in our dreams. To ignore their meaning is to ignore the universe within.

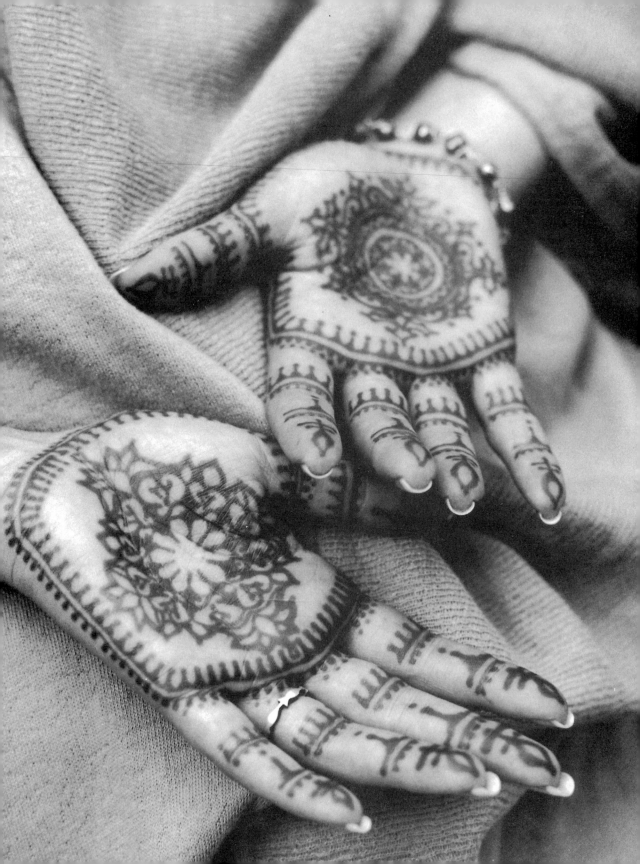

Designs for the Hands

The art of mehndi is a tribute to the hands. In this unusual medium where leaf is to skin as paint is to canvas, a magical relationship occurs between the hands and the healing dye left upon them. Henna stains the palms a deeper and more lasting color than any other part of the body. Just as the beautiful designs of mehndi distinguish and accentuate the uncommon nature of the hands, so should we.

A WELL-TRAVELED BRIDGE

It is easy to take our hands for granted. They serve us constantly. We rely on our hands for countless everyday tasks. They are the facilitators—those with which we give and receive. But whether making money or music, farming the land or healing the sick, our hands remain our most-traveled bridge to each other. It is the hands that we join in greeting or farewell, in worship or in wedlock.

Mehndi celebrates the hands as a miracle of creation and a vehicle of love. It focuses our attention on the sacred nature of the hands' activities. Here instrument in turn becomes canvas. From the hand to the hand, the henna flows a deep red into patterns of personal meaning, defined by and redefining tradition.

Mehndi is a unique form of painting because it not only honors but requires contact. Human touch—itself a medium of expression—adds another dynamic dimension to this work. The unlikely result of one person's desire to paint and another's desire to be painted is that they will probably end up holding hands for quite some time. This is an uncommon way of getting to know someone and an important opportunity for both people involved.

HEALING HANDS

As well as a celebration, mehndi provides a much needed vacation for the hands. Henna painting requires that the recipient be free of all responsibilities for the duration of the application, which can last as long as a full day and evening. Taking the time out to do this is in itself a healing thing, and when done in the proper spirit, it can be a rare and welcome break from the hectic routine of day-to-day life.

There are many healing elements in this practice aside from the medicinal properties already mentioned in Chapter One. Many women suffer the ill effects of having their hands in water for a good part of the day. For centuries, henna has been called upon to soften and rejuvenate the skin in the same way that it conditions and revitalizes the hair.

The process of having mehndi done involves important elements of massage and meditation. It requires stillness and concentration, as well as sustained physical contact with another person. The paste is cool and soothing to the skin; fingers must remain extended, hand open, and palm upturned. Of the many healing elements of mehndi, not the least is the warmth and comfort of having one's hand held.

SENSITIVITY AND SENSUALITY

More sensitive than any other part of the body, aside from the mouth and tip of the nose, the human hand contains up to thirteen hundred nerve endings per square inch. The hand generates heat, an essential ingredient in the henna painting process. This, as well as the thickness of skin, makes the inside of the hand the primary canvas for this form of painting. The Hindu bride will have the backs of her hands painted as intricately as the palms, with the idea that each hand then becomes two, and she will have four hands with which to give pleasure to her husband.

Henna painting celebrates and accentuates the erotic and sensual beauty of the hands. For Westerners it provides a way to feel touched by the exotic. There is something magical and exciting about having one's hands decorated with henna while knowing that for centuries it has been associated with romantic ritual.

THE FINGERS

The fingertips are a good place to begin discussing the sensual nature of designs for the hands. Fingertips may be dipped in henna. This is a traditional method of finger work in India, and though it may seem extreme to us, it is deeply associated with eroticism and feminine beauty. It is also a popular technique in Middle Eastern henna, as evidenced in the *Juti* and *Rawayid* styles of the United Arab Emirates which are discussed in the next chapter.

Henna will stain the fingernails a deep and lasting color that will remain several months and grow out with the nail. Several thousand years ago in Egypt, it was considered ill-mannered to venture out without one's nails hennaed. Nowadays, with the popularity of elaborate nail painting, an organic product that dyes the nails instead of covering them is an in-

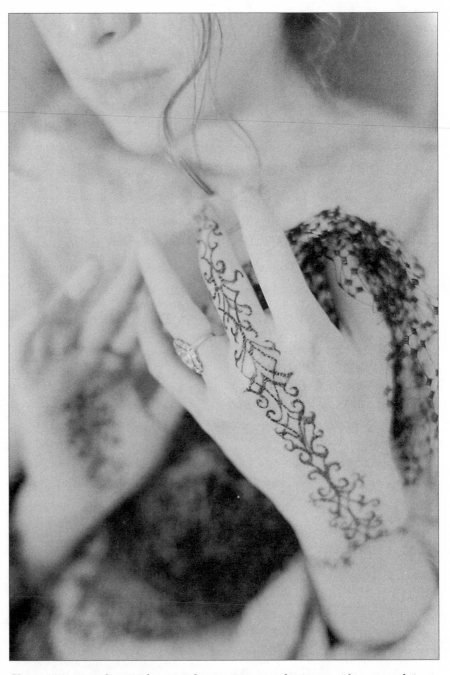

*Transient, miniature, domestic, decorative, these inscriptions are the signatures of women on their
bodies, ambiguous, subversive and subverted texts of a self secreted and celebrated in the body.
The representation not only captures, but sets free its subject.*

<div align="right">

—KATHERINE YOUNG, "WEDDING SONG..."

</div>

teresting option. In India, women decorate their nails with mehndi designs after having a child, as these designs are thought to bring protection, good luck, and a speedy recovery to the new mother.

The fingers are a very dynamic part of the mehndi experience. Some of my favorite mehndi designs involve only the fingers. For the mehndi artist, working with the fingers poses a challenge because they are narrow surfaces with vanishing horizons. They take the color quite well, though designs on the back of the fingers may fade a little faster than those on the inside. Traditionally, finger patterns are done in a number of ways. They may simply decorate the top or inside of the hand or wrap like rings or ribbons around each finger. Patterns may be done to match bracelets or rings or to imitate traditional Indian jewelry. For instance, a ring of henna on every finger may be joined by a thin thread of color to a central medallion on the top of the hand, which is then joined to the wrist. This produces an effect best described by imagining tiny chains attaching one's rings to the top of one's bracelet. Of course there are many simpler options. A small design painted at the base of the thumb or running up the side of the palm to the pinkie can be very lovely.

My favorite finger designs are from the Moroccan tradition. Sparse and striking in their simplicity, they often cover only a single finger or area of the fingers. There are many exciting variations of this form. Some designs extend from a single finger over the top of the hand to the wrist.

THE BACK OF THE HAND

The back of the hand is an elegant surface for mehndi designs. One of the most versatile designs for the hand is that of vines, which weave and wrap their way unpredictably from fingertip to wrist. Fluid, graceful, and simple to do, the creeping vine drawn on the back of the hand is known

in India as *B hai ki bal.* Connected with happiness and well-being, vines are a great way to incorporate scars, age spots, or any irregularities of the complexion into the design.

The back of the hand is a temperamental surface. If the skin is tanned and dry, it can be difficult for the color to take. People who use their hands a lot often think they will have a longer lasting pattern if they do the back of the hand instead of the palm. This is not true. With few exceptions, mehndi will last the longest on the palm. For those concerned with longevity, it is important to stress that designs on the back of the hand may fade (with average washings) in anywhere from a week to ten days.

The top of the hand provides an entirely different painting experience than the palm. Specific designs seem better suited to a convex surface than to a concave. Perhaps this has to do with the function of the parts. The palm evokes images of opening and offering (the sun, a flower, or a mandala), whereas the back of the hand acts more as a shield—closing, clenching, defending. Many of the motifs I choose for the top of the hand draw their inspiration from ironwork or symbols of protection, such as those used in Morocco to deflect the evil eye.

THE PALM

For the henna artist, the human hand is an incredible canvas full of mystery and character, and the palm is its center. Its already-existing patterns and lines provide a perfect springboard for the imagination—an irresistible invitation to innovation and improvisation. The color of the skin on the inside of the hand is often much lighter than that on the back of the hand. This, as well as the temperature and thickness of the skin, yields dazzling results when mehndi is used on the palm. If proper care is taken and the mud is left on overnight, the pattern will turn a deep red

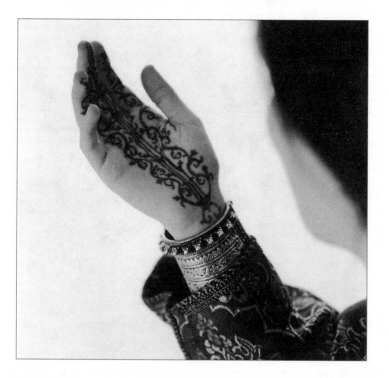

color with crisp, clearly defined edges. When the hand is unusually warm, the color may even turn black.

Circular or spiral designs are compelling shapes to use in the center of the palm and are my patterns of choice. Concentric circles, evenly spaced as in a target, provide the perfect foundation for an intricate mandala. Embellishing this central form is a traditional technique in mehndi and an exciting improvisational format for the artist. The more elaborate work is usually done within the circle, leaving negative space around the outside of the motif.

TRADITIONAL DESIGNS FOR THE HANDS

Frequently people ask for the traditional hand designs. These take a variety of forms. Traditional could mean the *Nagsh* patterns of the United

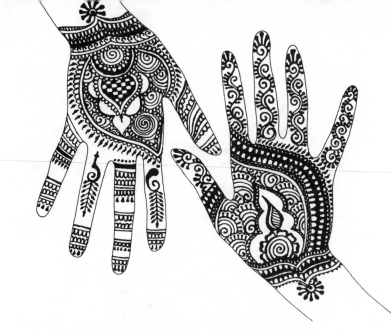

Arab Emirates (see Chapter Four), the sublime geometric patterns of Marrakesh, or the elaborate filigreed work of Pakistan.

In India, traditional mehndi is dense and intricate like a lace glove. One traditional format for this work is the use of a square or rectangular border that covers the entire palm. This is referred to as Old Mehndi. I have seen many beautiful examples of this technique, which creates its own frame for a magnificent and intricate field of design.

It is a popular custom in India to choose a symbol or design for the palm that may then be incorporated into or enhanced by the mehndi patterns. Paisleys, vines, peacock feathers, or spirals fill the palm from fingertip to wrist, often surrounding a central motif, like a peacock or *sakarpara* (a type of sweet shaped like a diamond).

HYBRID DESIGNS

My favorite patterns are hybrid designs—adaptations of traditional methods, which are inspired by individual hands. The vast menu of styles

available from the many different cultures practicing this art allows a contemporary artist to make exciting choices. I might choose something African for the fingers while placing an opening lotus at the center of the palm. There are so few boundaries set by our culture. For instance, the fine geometric work of the Moroccan henna artists can inform and influence our decisions, without any of the limitations imposed by religious doctrine (such as, the prohibition of representational images in Islam). These restrictions have created a wide range of options within a limited form, and we enjoy the privileged position of feeling free to learn from, adapt, and expand upon centuries of experience.

This makes it interesting to take requests, since each person brings something new to the experience. A woman who played the congas wanted a cobra winding down her arm to her palm and coiling around her wrist in a long diamond pattern, head pointing towards her thumb. She would return for a touch-up whenever her snake started to fade.

A landscape architect inspired me to paint a tiny tree (no more than an inch tall) in the center of her palm. It was a sweet image that had personal meaning and made everyone smile.

BOTH HANDS

People often request designs on both hands. This is quite a challenge for the person being painted, since it means that he or she is unable to open a door or reach into a pocket for several hours. In traditional henna painting it is common to decorate both hands. Whether for the *guedra*, or love dance, in North Africa or for a wedding in Singapore, the power of this medium is best illustrated in designs that honor the symmetry of the human form.

Some designs start in one hand and finish in the other. A variation on this theme is the design that creates a mirror image of one hand in the

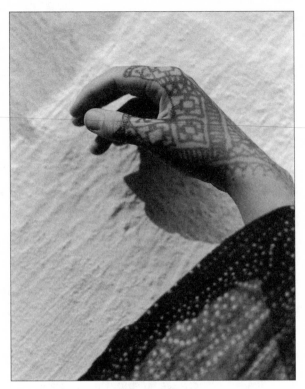

other. (According to Indian palmistry, the right hand symbolizes the man, and the left the woman.) Mirror images in henna paintings are intended to show the union of the masculine and feminine principles.

Among my favorite mirror patterns is the figure of a bird, wings spread across the palms and the backs of both hands (see page 11). Actually, there are four birds, one on each hand, whose bodies form on the pinkie side, each with a wing wrapping round the palm and the back of the hand and two more which form when the hands come together. As mentioned in Chapter Two, the bird is considered a spiritual messenger traveling between the heavens and the earth.

One couple asked to have one bird painted on each of their hands. One of them was leaving on an airplane trip the next day, and they wanted a picture taken of their hands together, forming one bird. Their hope was to reunite before the henna pattern faded.

Full hand work frequently extends beyond the palm or back of the hand onto the wrist. I have already mentioned that the skin on the top of the hand may not take the color as deeply as the palm. The skin of the wrist and the arm poses a different challenge. Not only will the dye not take as deeply, but the color may be different from that of the rest of the hand. (Color and intensity may also vary from the inside of the wrist to the top.) Hair on the skin, which usually begins at the wrist, prevents the thin lines of henna paste from lying directly against the skin; chances are that the color will not take well. In cases like this, bold, simple designs are a better choice.

Despite the inconsistencies of skin types, hair, or temperature, the wrist and the arm present exciting possibilities for accentuating and elaborating upon hand and finger designs. Full hand work traditionally trails off the palm in an intricate, tapered edge. For the Hindu or Moslem bride, it is often a point of great pride to extend the mehndi up as much of the arm as the wedding dress will show. The length and intricacy of the mehndi are admired as would be an expensive necklace or garment. It is an indication of wealth, taste, and stature.

Variations on these elaborate traditional forms can be elegant and exciting. One example is a lacelike cuff that extends from the wrist like a sleeve, with the fingers remaining bare. Or perhaps a pattern all around the outline of the hand, following the same line as a pencil tracing but running all the way down the sides of the arms? The possibilities are infinite.

In keeping with the true spirit of mehndi, no two patterns are ever exactly alike, just as no two hands ever could be. This art form visually enhances an area so seasoned with sensory experience, so full of the life force and energy, that in the best of cases it will feel as though the dye is bringing a power, already present, to light.

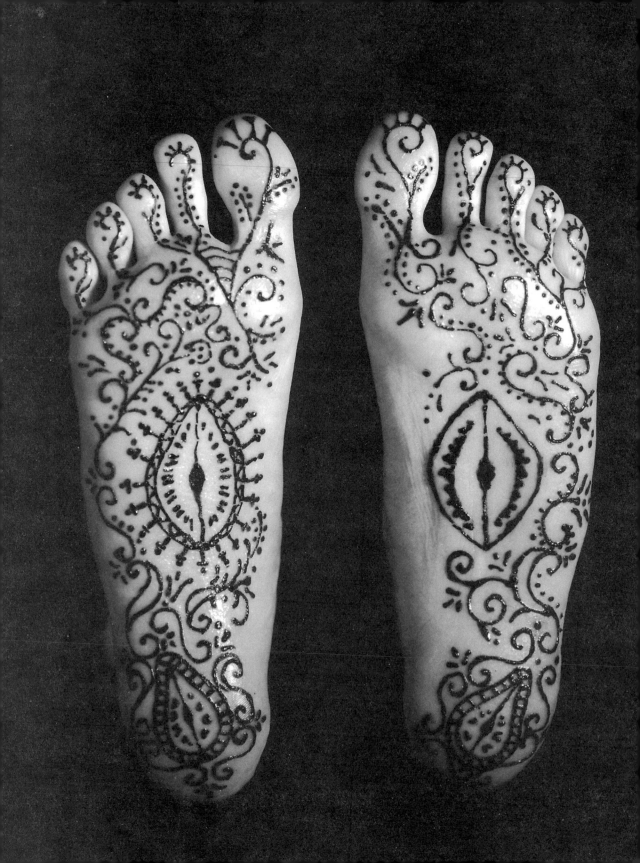

Henna for the Feet and for Other Parts of the Body

Feet. Think about what we do to them. We stand on them, walk on them, shove them into unreasonable shoes, and turn up our noses when they start to smell. High heels, itchy hose, damp socks, shoes with bad straps or pointy toes—these are home to the Western woman's foot. At best, the average woman can go out and get a pedicure after abusing her feet unmercifully.

The female dancers of India adorn their feet with henna or paint. They tie strips of small bells to their ankles to accent the dynamic rhythms of the dance. They emphasize the natural movements of the foot, flexing it and placing it with elegance and skill.

Western ballet dancers, on the other hand, simulate the otherworldly. Their movements are fantastic, ethereal, not human. The beautiful lines and shapes of their bodies are achieved by forcing their feet into painfully unnatural positions or binding them into toe shoes. These serve our ideals of beauty. No wonder we ignore our feet as sensual instruments of grace, strength, agility, and eroticism.

A DIFFERENT PERSPECTIVE

In India, the feet of a woman are given an entirely different kind of attention than in the West. The soles of the feet are recog-

FACING PAGE:
The man who speaks with primordial images speaks with a thousand tongues. . . . That is the secret of effective art.

—H. E. HUNTLEY

nized as a point of divine contact, the place where the human being and the earth meet. This is considered a holy junction.

The art of mandana celebrates this union. *Mandana* is the ancient practice of painting or tracing elaborate patterns on the floor of a home or dwelling. These designs are considered a symbol of welcome and are often painted in doorways, starting inside or outside the threshold. They are usually made with rice flour or traced into earthen floors and are intended to disappear over the course of the day. Many of the symbols used in mandana designs are similar to those used in mehndi. Mandana paintings include stylized representations of feet or footprints.

The footprint of a human being is also held in high regard, and many ritual practices involve an awareness of its symbolic significance.

For instance, at the time of marriage, the footprints of the bride's and groom's in-laws are made in saffron on cloth. These imprints are called *paglyas,* and they are worshiped for a year before being immersed in water in ceremonious conclusion of the ritual. Similarly, tiny footprints are marked with henna paste on either side of the door to a room where a

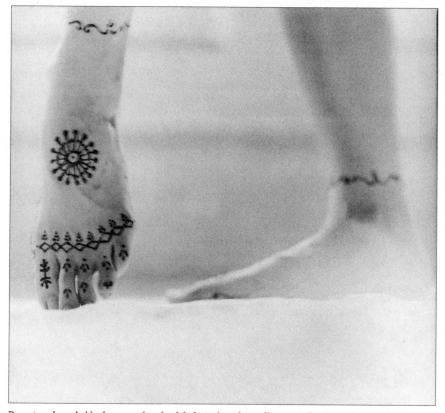

Born in a household where people take delight in but also walk on mándanás, paglyás, and other related designs that have accrued in the artist's mind around symbols such as the cross, the hexagram, and the lotus flower, a child held and caressed by his mother's hand decorated with mehndi absorbs the unspoken message of these designs and their rhythms. If the child is a daughter she will learn to create a ground of beauty which, in turn, she herself will be able to prepare and pass on.

—PRIA DEVI AND RICHARD KURIN,
FROM *ADITI, THE LIVING ARTS OF INDIA*

child is born into the world. A profound religious sentiment is revealed in the practice of feet worship as it exists even to this day.

There is a lovely myth about the birth of the Buddha that further illustrates this point. It is said that when Buddha was born, he took seven steps from his mother's womb, and lotuses sprung up from his footprints.

On a darker note, according to Jogendra Saksena, it was a belief in

India that you could kill a man by "removing the earth of his footprints and working magic on it."

Henna is used not only to beautify the feet but also to celebrate them as instruments of divine making. When an Indian bride takes her first step into the groom's home, it is considered a very auspicious occasion. Her feet are intricately adorned with henna and jewelry. In Hindu wedding ceremonies, the bride and groom are believed to represent something far greater than themselves: the union of the feminine and masculine principles—the creative powers of the universe. Since the goddess Lakshmi is thought to dwell in henna designs and also to be embodied in the being of the Hindu bride, welcoming the bride is like welcoming Lakshmi herself into one's home. The floor is painted with elaborate mandana designs, and the bridal bed is strewn with flowers.

THE PRACTICAL FUNCTION OF HENNA
FOR THE FEET

The use of henna on the feet probably began for purely practical reasons. Because henna draws heat from the body, the nomadic tribes of Africa and the Middle East used it to cool the soles of their feet and to protect them from the burning sands on which they traveled. It was at first a great mystery to me that henna was often discussed as a cure for headaches. It turns out that this is accomplished by putting henna on the soles of the feet. As strange as it may sound, henna on the feet is considered "healthy for the eye" (*sihhat lil 'ain*). Soreness of the eyes, like headaches, is a symptom of heat exhaustion. Applying henna to the soles of the feet alleviates the symptoms by insulating the body from the intense heat of the sand. Henna is also used as a cure for athlete's foot, foot odor, corns, blisters, minor cuts, and abrasions.

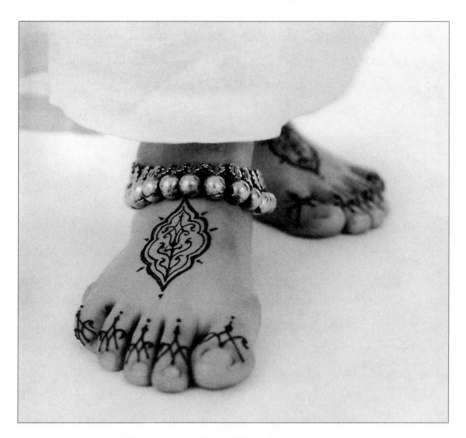

PAINTING THE FEET WITH HENNA

Henna will stain the sole of the foot as deeply in some spots, as it will the palm of the hand. The color will be darkest on the heel, on the ball of the foot, and on any area where the skin is callused or thick. Henna on the border of the foot will also get a rich color, while on the top of the foot and the ankle, it tends to be lighter and fade faster.

Just behind the ankle is a mysterious little area of delicate skin that resists the dye. You may not notice it at first, but it is one of a few odd "vanishing spots" where color will not last too well. Similarly, there is a spot in the center of the sole where the foot makes least contact with the ground. Henna in this area of the arch will often remain much lighter, creating a beautiful contrast with rest of the foot. It tends to stay a

bright orange, while the ball of the foot and the heel stain burgundy or black. You may want to consider this when planning the design and incorporate the color difference into the pattern.

DYEING THE SOLES

People are either enchanted or dismayed when they consider the possibility of dyeing the soles of their feet. Anyone who has had mehndi done knows that the greatest challenge comes after the designs are completed. Henna should be left on for at least several hours, preferably overnight. Since you can't walk while the henna paste is still on the soles of the feet, you have to be patient and inventive. It can be difficult to keep one's feet from touching the ground for any substantial length of time. Many people I've painted have had to be carried around, which is about as inconvenient as it is amusing. This lends yet another memorable dimension to a bridal shower since it is often the request of an American bride to have her soles painted in order to conceal all evidence of exoticism inside her wedding shoes.

This symbol of God's feet often appears in the art of Mandana, where floors are covered with sacred and ceremonial designs.

One bride whom I worked with drank a lot of champagne while she was being painted and had to be hauled to and from the bathroom, in a chair, by two men. Some of the funniest stories from my work as a henna painter involve doing intricate work on the soles of women's feet and then helping them to deal with the practical details of the experience, like how they plan to get home. I have seen many a woman hopping into a cab or carried out the door by friends and loved ones. After one bridal shower held at Bridges + Bodell gallery in New York City in 1996, the entire group of women carried the bride down the street and then paid a man passing by to carry her the rest of the way.

There is a wonderful description of the process of painting the feet in Aida Kanafani's book *Aesthetics and Ritual in the United Arab Emirates.* (The designs mentioned here are not intricate patterns, but large areas of color covering the entire sole.)

To dye her feet the woman being dyed lies on her back on a rug which is covered with a jute cloth to receive the dropping or drying crusts, legs straight and lifted at the ankle level with a low stool. A pillow is placed under her head to provide some comfort as the dyeing of the feet is a lengthy process. The other woman who applies the henna must use her hands as the henna paste is liberally applied to the sole, the sides of the foot and the edges of the toes with equal thickness. Once both feet are covered with the substance, the woman continues to lie down with her ankles slightly separated to avoid touching which might blur the design. Another application is necessary to acquire a blacker hue, and when the henna on the skin dries, it breaks off as it cracks from various spots. The crusts may either fall by themselves or the women may pull them off. Most frequently, women go to bed with the paste on their hands and feet after wrapping them with a piece of linen. This is also done for children who may otherwise stain the bed sheets. Overnight the henna dyes black, and no further layers are necessary.

Often I recommend making use of such modern conveniences as the sofa and the television set. Having your feet hennaed is a great time to rent a couple of movies and order in. Ideally, you want someone there whose feet have not been painted and who has happily agreed to pamper you for the remainder of the evening. My other advice: don't drink a lot of water, or anything else for that matter.

One of the questions I am frequently asked is "Does it tickle?" The answer is no, not in the application process. When it tickles the most is

while scraping it off. Of course, if you're painfully sensitive, you can al-ways rinse the henna off with water, but this does not give you the depth of color you get from scraping.

PATTERNS AND DESIGNS

Designs for the feet include the bold and striking patterns of the desert, nomadic, and rural communities. These designs are simple and utilitarian, which does not detract from their profound beauty or religious signifi-cance. Using strong lines and following three basic styles, these patterns from the United Arab Emirates provide a wonderful contrast to the or-nate patterns of Morocco and India. I have included the corresponding hand designs to provide a better sense of the style of this work.

Figure No. 1: *Gassah* (taken from the word *qassa*, which means to cut): Notice the curve on the side of the foot, beginning at the arch.

Figure No. 2: *Juti* and *Rawayid*: In this technique, there is no curve at the arch the way there is with the gassah. The difference between rawayid and juti has only to do with the dyeing of the fingers, one to the first joint, and the latter to the second.

Figure No. 3: *Ghamsah* (to dip): This is a style frequently used by the elderly. The foot is immersed in henna all the way to the ankle, and the hand to the wrist.

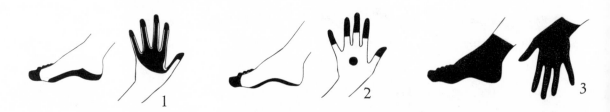

Compare these to elaborate geometric patterns of Morocco or the swirling arabesques and flowering vines of India. It becomes clear that these more elaborate designs take on a different significance. The emphasis here is on beautification and celebration.

Everything about this practice shows a deep respect and consideration for this part of our bodies, which we rely on so heavily and reward so little.

In Morocco, the opportunity for creative expression is an invitation to worship. As mentioned in Chapter Two, every mundane task is believed to have transformative potential. For the urban women of Morocco—citizens of Fez, Marrakesh, or Casablanca—a different style of living creates

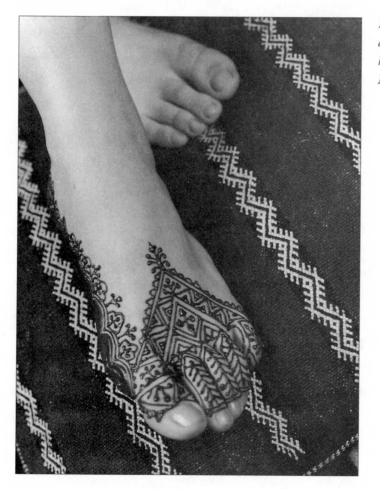

It is not easy to distinguish between pure decoration and magic in the beautifully henna-painted feet of the women all over Morocco. . . .

—H. REINISCH AND W. STANZER,
FROM *BERBER*

a different emphasis in their work, one based less on pragmatism and more on skill and artistry. The designs are therefore intricate and lacelike, covering the top of the foot and sometimes extending up the leg, usually no farther than the ankle.

Most of my favorite border motifs for foot work are Moroccan. They work so beautifully with the almost architectural structure of the foot and leg. The hand is a mysterious opening flower, but the foot is like the lopsided base of a Doric column or the roots at the base of a tree. It is meant not to hold, but to hold up.

My hope is that by learning about various traditions of painting the feet with henna, Westerners will learn a greater compassion for this part of the body. (The film *Kama Sutra* is worth seeing just for its sensual and sensitive attention to the female foot.) If this practice can encourage women like me to see their feet as more than just a vehicle of transportation, perhaps that's reason enough to call henna a magical plant.

OTHER PARTS OF THE BODY

Henna is used traditionally on other parts of the body as well, but this fact is rarely spoken about. One learns of these things only from books or Western women who traveled to places like India and were invited as guests to attend prenuptial henna ceremonies. Occasionally, the inner thighs and pubic region of the bride will be painted with patterns as well.

One woman told me a story of her grandmother who lived in Iran. For her wedding she had poetry written in henna all the way up her leg. Bridal designs, as I mentioned earlier, will often cover large portions of the arms and the legs. Intricate patterns extending above the elbows and

ankles are expensive and time-consuming and are done primarily to emphasize a family's status and wealth.

The color that the henna will stain the skin will vary according to the individual and to the different areas of the body. The skin on the inside of the arm is generally paler and tends to get a more vibrant color than that on the outside of the arm. The inner arm also takes the color better because there is no hair. Henna on the upper arm varies from person to person. A lot seems to depend on circulation. The same seems to be true of the legs, in which case the color also depends on the method and timing of hair removal and on the dryness of the skin.

People new to henna painting frequently want to paint necklaces. However, the skin of the neck, shoulders, and collar bone area is thin, exfoliates quickly, and does not get good color. It is also very difficult for the person being painted to keep her neck still. Even with multiple applications, designs fade quickly, lasting on average no more than a week. The same is true of the face, which is perhaps the most henna-resistant area of the body.

The belly, if it's warm, can do quite well, though tiny soft hairs on the skin of the stomach can prevent the paste from making contact with the skin, especially if the woman is not painted lying down. In general, the belly is difficult because of the challenges it presents to the client. Keeping the paste on and allowing the dye to penetrate require stillness. You can't sit, bend, drive, or pull up your pants without the pattern smearing or cracking off.

The back gives varying results, but like the chest it exfoliates quickly. On the breasts, the stain tends to be light, but if the skin on a woman's breasts is pale, the design may appear deeper and more pronounced.

In general, understand that henna responds to heat, and wherever there is warmth, like the inner thighs, the color is going to take a lot better than on the cool, thin-skinned areas of the body.

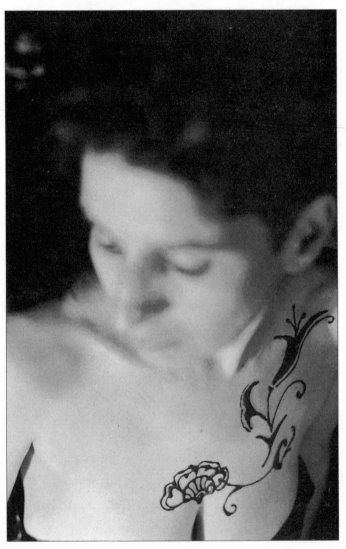

Painting renders the surface of the body an aesthetic space.

—KATHERINE YOUNG, FROM
"WEDDING SONG . . ."

THE CHALLENGE OF EXPERIMENTATION

Mehndi is a medium traditionally used for the hands and the feet. This is where the color is most dynamic and the designs most compelling. Women in the West are just learning about henna painting and have none of the cultural restrictions of those who practice this art form traditionally. We don't have to veil our faces or cover our bodies from head to

toe. Here, more skin is exposed, and people will naturally be interested in trying to paint other parts of the body.

But it is important to understand the limitations of the medium. It's hard work for the person being painted to try to sit still long enough to have elaborate body work done. Painting on thinner, cooler skin usually

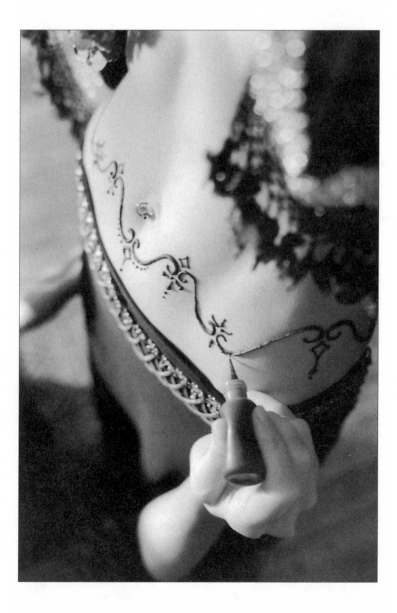

necessitates reapplication to get a dark enough color and will still fade in much less time than painting on the hands and feet.

Nevertheless, it is safe, fun, and irresistibly tempting to try using henna all over the body, and because each person is different, the results may be as well. You never know until you try.

Getting Started

God makes the earth yield healing herbs, which the wise one
will not neglect.

—SIRACH 38:4

The first challenge of working with henna is finding it. Purchasing a
fine, fresh henna is the most important step of the process. I highly rec-
ommend consulting the Resource Guide at the end of this book in order
to save time, money, and energy. Since the opening of The Mehndi
Project in 1996, many new products have appeared on the market, and I
have tried testing and grading as many as I can. A top quality henna will
provide a decent color on the skin, even when mixed with just water. I
have listed names, addresses, and numbers of suppliers so that readers
should have no problem purchasing the best products available.

SHOPPING FOR HENNA

There are several places where you can look for henna: Indian, Islamic,
Middle Eastern, or Moroccan stores; herb or spice shops; health food

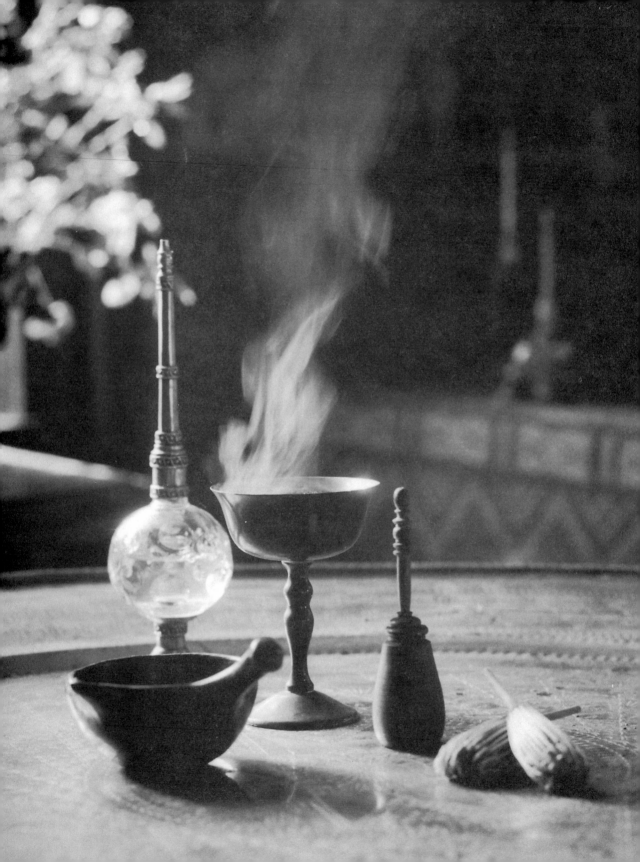

stores; aromatherapy or specialty body-care shops; and even some natural pigment supply companies.

Shopping for henna and other supplies can be an exciting and enjoyable part of the preparation process. Let the pursuit of ingredients and tools open new doors and provide the excuse for exploring other cultures and ways of life. Look in your phone book to find a nearby Indian or Middle Eastern supply store. If you have trouble finding one, look for the closest Indian restaurant, and see if the staff can give you any tips on local suppliers. (For those who live too far from such places, I have provided names and phone numbers of stores willing to do mail-order business.)

An Indian store is a wonderful place to begin your relationship with mehndi. Immediately, you will feel like you are in another world, one of unfamiliar smells and shelves full of mysterious goods, including spices and foods. The oils, medicines, and cosmetics are quite different from those we are familiar with here in America. Similarly, a Moroccan store may sell beauty products like kohl for the eyes, natural barks to whiten the teeth, and orange-blossom or rose water to use on the body or in food.

If you intend to buy henna from a store, there are several things you can check for. First and foremost, be sure that the product you intend to buy is for the skin and not for the hair. Henna that is sold to color the hair is often chemically treated and consists of tiny twigs and bits of leaves instead of the fine powder necessary for mehndi. This henna is not fine enough to pass through the small tip of a mehndi bottle or cone. You cannot remedy this problem by grinding the henna the way you might a coffee bean or spice. You can try sifting it, but you may lose a large percentage of your product in the process. In general, using henna meant for the hair is a waste of time and money. There are some exceptions to this rule, but very few.

I also suggest that you take this book with you when shopping for

mehndi in a store. The quality control can be poor on products imported from India and the Middle East. I have purchased many packages of henna that fail to leave any stain at all, as well as products that were opened, expired, half-used, or not even in the container!

If you find a product on the shelf that is not listed in the Resource Guide, here's what to look for. Make sure that the box or bag is sealed and has not been opened. At times I've brought a box of henna home and then discovered a small piece of scotch tape sealing a corner or a tear. Check to see if there is an expiration date on the box. One product I purchased had the date "corrected" in magic marker. If the package says "black henna," chances are that the henna is no good. If the illustration on the box shows mehndi designs in black, it could just be that the picture is showing a hand or foot with the paste still on. This is common and has no bearing on the quality of the product.

If you're buying henna in bulk, there are a few things to be aware of. Henna sold this way usually comes in three colors: black, which is for the hair and will not leave a mark on the skin; neutral, which is meant to leave as little color as possible and is also not intended for mehndi; and red, which is what you want to buy. Don't bother asking the people who work in the store.

The henna powder used for mehndi should be as fine as talc or baby powder. There can be no bits of twigs or splinters of leaves if you intend to do delicate designs. Most henna sold in bulk will need to be sifted several times. If this henna is sold for eight to ten dollars per pound, you can be sure that at least 30 percent of it will not be of use for mehndi. Sometimes as much as 60 percent of the henna you buy will have to be discarded or used for other purposes, such as dyeing the hair.

The quality of the henna available in specialty stores and sold in bulk can vary dramatically. The advantage of shopping for henna in a Hindu or Moslem community is that you can be sure it hasn't been sitting

around for too long in the store since it is used for common ailments as well as cosmetic purposes. Try it. Buy a small quantity, and test it at home. If you are lucky enough to be in an area where several stores carry fresh henna, then trust your sense of smell when choosing which henna to buy. A fresh top-quality henna will be noticeably fragrant, like a fresh herb. Often the color will be green, though sometimes it can be more of a raw umber or brown. (This should not be mistaken for neutral henna, which is always pale brown in color.)

COMMON MISCONCEPTIONS

Henna stains a reddish color but can appear anywhere along a continuum from pale orange to deep rust or sienna. There is no such thing as henna that is truly black. Henna paste dries black as it dyes the skin, and the photographs that you see in which the henna appears black in color are usually pictures taken before the paste was scraped off. A strong-enough henna will sometimes stain a blackish color, but only because the red color deepens to black. A thick layer of paste, as with dipped fingertips, will go black quite easily, but the thin lines of the more-delicate patterns are unlikely to do so. When they do, it is usually the result of multiple applications or of leaving the paste on the skin for a long time with proper heat. Anything else involves chemical additives.

Henna does come in different shades but not in different colors. The color of the henna may be affected by substances added to the recipe, but if you're going around looking for black or blue or purple henna, you won't find it. I suggest you locate a fresh, strong, natural henna, and then begin learning recipes and application techniques.

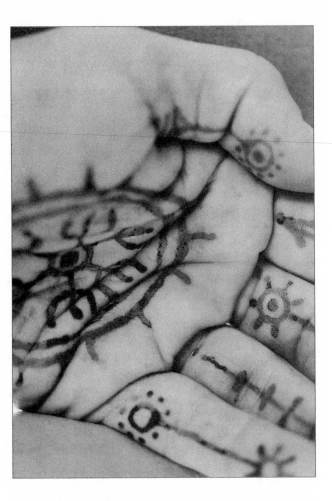

There is colour in every leaf of mehndi, but it can be obtained only after grinding them.
—JOGENDRA SAKSENA,
FROM *ART OF RAJASTHAN*

WARNINGS

Much of the henna available on the commercial market is chemically treated. On the box, the ingredients may be listed as "100 percent pure henna." What they fail to mention is what's been done to it before it was packaged. This henna will often give off an unpleasant, toxic odor. Don't waste your time with a product that looks gray or has an artificial, noxious smell.

Also beware of pre-made pastes sold in cones or tubes. Real henna paste is perishable and will only stay fresh for two to four days. Ready-

made pastes are prepared with preservatives, and their effect on the skin is, at best, questionable. I do not recommend such products. If you are interested in buying henna that is already made, you can order it from a number of places, but you must be prepared to pay more for overnight delivery than you will for the actual product. Nevertheless, I have listed some very reliable sources in the Resource Guide at the back of the book.

If you have opted to order pre-made henna from a local artist or salon, be sure to request that no harsh substances such as turpentine, kerosene, or clove oil have been added to enhance the color. If you smell anything odd in the paste, be sure to ask what mordant has been used. Always test a new product on a small area of skin before using it.

Another and more recent development is the manufacturing of mehndi products within the United States. When The Mehndi Project had its first exhibition at the Bridges + Bodell gallery in 1996, there were no Mehndi products manufactured in the United States. Now, little more than a year later, there are dozens.

Most of these products are extremely overpriced and filled with unnecessary clutter like cheap applicators, stencils, oils, or additional ingredients. What they don't have is enough henna. In some cases they have no henna at all! (One Mehndi kit I ordered was just red paint.)

If you have had a negative experience with one of these products, chances are you haven't experienced true mehndi at all. Currently, a decent unsifted henna costs about $12.00 a pound. If you're paying $16.95 for three ounces, you're paying way too much.

OTHER INGREDIENTS

There are several ingredients that can be used to make mehndi paste—most importantly, black tea. I like to use a generous portion of tea leaves

when making tea water for henna and have found it to be most effective and economical to buy tea in bulk from small stores. Ask for the darkest tea available. Many times this will be a Ceylon black.

Dark coffee is also used as an ingredient in making henna paste. For this I like to go to Middle Eastern stores, but any place selling exotic coffees and teas will do. Be sure not to purchase flavored coffees or light beans. The darker the bean, the darker it will color the henna.

Another ingredient used to deepen the color of henna is tamarind. A popular Indian food, tamarind is a fruit usually sold dried, in rectangular packages about six inches long. It currently costs about three dollars a pound. I find that the best tamarind for henna comes from Thailand or India; the fruit from the Dominican Republic is too light in color. Tamarind also comes in the form of a concentrate, which may also be used in preparing henna.

Other ingredients to look for in Middle Eastern or Indian stores are cloves, mustard oils, and eucalyptus oil. You can buy whole cloves in bulk and spend only a few dollars per pound, or you can pay the same amount for a tiny jar sold in the spice section of your local supermarket. Mustard oil is a product that I use all the time, and I've never been able to find it anywhere other than in an Indian store. Mustard oil will smell like a good strong mustard, and in many cases it will be labeled "for external use only." Check the Resource Guide for more information. Eucalyptus oil can be found in an Indian store or a health-food store. It will probably be more expensive in health-food stores, but chances are it's a higher quality oil. Be sure to look for essential oils sold in tinted glass bottles, as these substances are sun-sensitive and need to be stored away from the light.

Many of the items listed here serve functions explained in later chapters. Each plays an essential role in the making and application of mehndi paste.

The most basic tool that you will need to purchase is your application device, or the ingredients to make your own. The products that I recommend are the Jacquard bottle and the traditional henna cone.

The Jacquard bottle is perhaps my greatest find for doing this work. I tried every form of applicator, from a pastry bag to a syringe, before discovering this wonderful tool. I found these dye bottles in a local art supply store and am still unsure of their original intended use. They are usually located in the crafts section of the store and sold alongside items used for dyeing or batiking fabric. They are half-ounce plastic bottles,

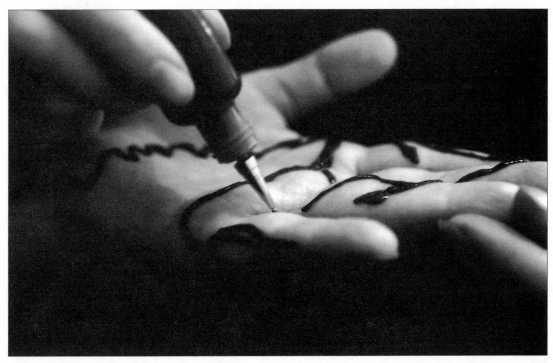

with metal tips sold separately in three sizes with .09, .07 and .05 centimeter openings.

Even if the Jacquard bottle becomes your dispenser of choice, you will still need to make plastic cones to fill the Jacquard bottles. There are other ways to do this, but the cone is a simple and effective method.

SHOPPING LIST

BASIC INGREDIENTS
Henna
Tea
Coffee
Springwater or Distilled Water
Lemons
Sugar

OPTIONAL INGREDIENTS
Eucalyptus Oil
Mustard Oil
Cloves
Okra
Tamarind
Garlic
Pepper
Orange-Blossom Water
Cardamom
Black Walnut Hulls (Ground)
Fenugreek Seeds
Pomegranate
Limes

BASIC TOOLS
Cone or Bottle (with Tip)
Scissors
Scotch Tape
Tea Strainer with Handle
Ceramic, Glass, or Wooden Bowl
Wooden or Plastic Spoon
Lemon Squeezer or Reamer
Porcupine Quill or Flat Toothpicks
Cotton in Balls or Strips
Heavy-Duty Clear Plastic Drop Cloth
 or Freezer Bags
Cotton swabs
Sifter

MISCELLANEOUS ITEMS
Coal
Incense
Cosmetic Make-Up Applicators
Pumice Stone
Loofah, Natural Fiber Cloth or Mitt
Candles
Heating Pad or Hair Dryer
Plastic Wrap
Gauze

Cone making requires a heavy-duty four-millimeter plastic sold in the form of drop cloths or freezer bags. It is also used to package a variety of products. (It's best to recycle it if you can.) Otherwise, you can purchase a nine foot by twelve foot super heavy duty drop cloth. This costs less than five dollars and will make enough cones to last you the rest of your life. Scotch tape is necessary to seal and close the cone.

Another item that you must have is a tea strainer, the kind with a handle and a diameter no smaller than an orange. Other necessary items include paper towels, cotton swabs, flat toothpicks, and cotton in balls or in strips. Be sure to buy 100 percent cotton, not the synthetic cosmetic puffs, which can cause real problems for the henna artist. You will also want to have plenty of lemons and sugar on hand at home, as well as small bowls and plastic spoons.

Specialty items include coal, incense, porcupine quills, coins, candles, and a variety of exfoliating devices. The coal that I am referring to is sold in small discs, stacked and wrapped in foil. You can find these at stores or stands where incense is sold—and if you buy incense in loose form, you can sprinkle a bit on the coal while it burns.

Preparations

SIFTING

The proper sifting of henna powder is a long and labor-intensive task. It is an essential part of the process unless you are buying presifted powder. Many companies may claim to sell a presifted product, but the true test is whether it will pass through the tip of your applicator.

NEVER BUY LARGE QUANTITIES OF HENNA WITHOUT TESTING IT FIRST. Before ordering the powder in bulk, people interested in doing

this work professionally would also be wise to ask (and test) whether the henna has been finely sifted.

You can immediately tell that a henna is unsifted if you see any twigs or large particles in the powder. Henna should look as fine as baby powder, though finding a sieve with mesh fine enough to sift it can be a challenge. Many women use cheesecloth, though this is a long and arduous process that must be repeated four or five times to be effective.

Frame drums are a favorite sifting tool in Morocco. Small holes will be punctured in the skin of the drum, and the frame can then be used as a container while the sifting is done.

Nylon stockings are a popular tool in the never-ending search for a finer henna powder. In Morocco they are sometimes stretched across a small wooden frame, forming a container similar to the inverted frame drum. Nylon stockings can also be stretched across a bowl or jar and secured with a rubber band. Some women force the henna through the toe of a stocking after making the paste. This needs to be done several times to be effective.

If you're using a sieve, try the ones used to make yogurt, which have a very fine mesh. However, these can only sift a couple of ounces at a time, and even that amount can take nearly an hour.

Henna artist and ceramicist Judith Hooper gave a great gift to The Mehndi Project when she discovered the Talisman sieve. The Talisman sieve is sold through ceramic supply companies and makes sifting henna a much more manageable experience. It is the size of a large mixing bowl, with a long handle attached to three brushes that force the henna through the mesh. Mesh is available in a variety of grades of fineness. Though this is an expensive item, if you are seriously interested in pursuing the art, it is well worth the money for the time and energy that you can save.

For even greater convenience (at greater expense), finely sifted, ready-

to-use henna is available. Check the listings in the Resource Guide for further information.

HOW TO MAKE A CONE

The cone is a basic tool in the art of henna painting. Even if you have purchased the Jacquard bottles or other application devices, I highly recommend that you familiarize yourself with this simple and practical technique. A mehndi cone is just a small plastic funnel. It resembles a miniature pastry bag. It is the most commonly used henna applicator in India and the Middle East.

Cone making is very simple. Cones should be made before you prepare the paste so that you have plenty on hand as soon as you need them. (See instructions on the next page.)

Before You Begin

TESTING FOR ALLERGIES

Testing for allergies is an essential step in this process. It is unlikely that anyone will be allergic to henna itself, but I have known people to be allergic to ingredients added, such as oils or even coffee or tea.

Test individual ingredients in small patches on several areas of the body. On some people the tender skin of the inner arm may respond differently than, say, that of the palm. It's best to know ahead of time that your body responds well to all of the ingredients.

CONE·MAKING INSTRUCTIONS

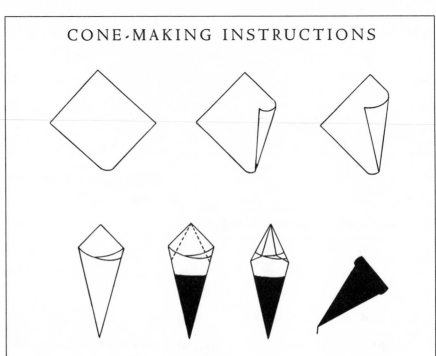

To begin, cut a rectangle approximately five inches by seven inches from the plastic. Trim the corner of one side to make a rounded edge. Holding the plastic between your pointer and your thumb, roll the plastic into a funnel shape until the opening at the tip is no bigger than a pinhole. Now tape the seam all along the side, and reinforce the tip with tape.

Drop in the henna paste, using a spoon. Make sure the cone is only half full; otherwise it will be too difficult to close.

To seal the cone shut, fold in the sides as though wrapping a gift. Fold the top flap about a quarter of an inch down, and continue to fold it again and again until there is no air or space left in the cone. Now seal every seam with tape. (You can also fold this in half lengthwise and wrap it with a rubber band.) Sealing the cone well is extremely important; otherwise the henna will leak all over your hands as you squeeze. Your cone is now ready to use. If you find that the opening is too small and no henna will pass through it, use a needle or pin to widen the tip. If you are using a cone to empty henna into small bottles, snip the end with a scissors, making sure that the opening is still small enough to fit inside the neck of the bottle. When storing cones meant for painting, a pin with a round head may be pushed into the tip. This will keep the paste from drying out and will keep the opening of the cone from clogging.

TESTING YOUR HENNA

Test the quality of your henna while you're at it. Paint a small spot on the bottom of your foot, and see how the color comes out. There's nothing worse than doing elaborate work with a henna that doesn't take. A simple way to test the powder is to mix it with a little water, let it sit for at least an hour, and apply it to the area. When it's completely dry, scrape it off. It will leave a visible mark if the henna is good.

PREPARING THE SKIN

To prepare the skin for henna painting, it's important to moisturize well in advance. You can improve the efficiency of the dye by using lotions or oils on your skin for several days before being painted, but don't use any on the day you're painted. Soft, well hydrated skin will take the color much better than skin that is dry or chapped.

Other preparations begin the night before. If you want to do designs on any part of the leg above the ankle, you will want the area to be free of hair. Shaving your legs the night before allows you to protect the skin from irritation, which can be exacerbated by oils in the paste.

You will also want to exfoliate your skin using a loofah, brush, cloth, pad, mitt, or pumice. In Morocco, you can find several wonderful exfoliation products unavailable here. One is a small textured mitt. Another is a small, woven disc filled with flax seed. (It's like a cross between a doormat and a circular bar of soap.) My favorite exfoliator is the Ayate washcloth made of maguey, a cactus fiber from the agave plant. Check the Resource Guide for more information on purchasing these items.

Create the right environment. Treat this as a break, not another task. Get as much of the work around the house done as you can so that you don't have to try to do too much the following day. Renting a good movie is the perfect way to spend an evening with henna on your hands.

Until you try it, you have no idea how hard it can be to function without using your hands. If you're having one hand painted, these are a few of the things you will not be able to do: drive, get money out of your wallet, cut your food, wash dishes, tie back your hair, or floss.

If you're having two hands painted, you can add these things to the list: opening a door, brushing your teeth, pulling down or pulling up your pants and all other related bathroom activities, feeding yourself, lifting a glass, changing the television channel, turning out the lights, or wrapping either one of your hands.

Perhaps this makes it easier to understand why women often fast before having henna done. Remember, it's best to take care of some things ahead of time, and try to have somebody there to help you out. Needless to say, you'd be wise to make it someone you're comfortable with.

All of this makes for a lot of fun if you choose the right people to share it with. If you're on your own, just paint one hand at a time. Wait until the next day to paint the other.

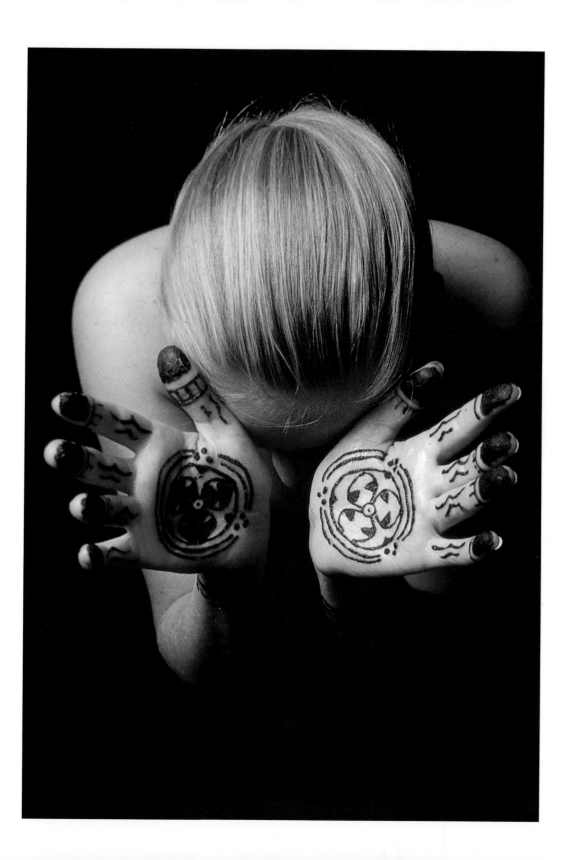

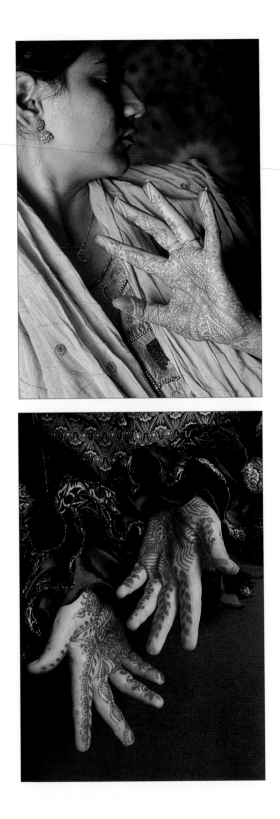

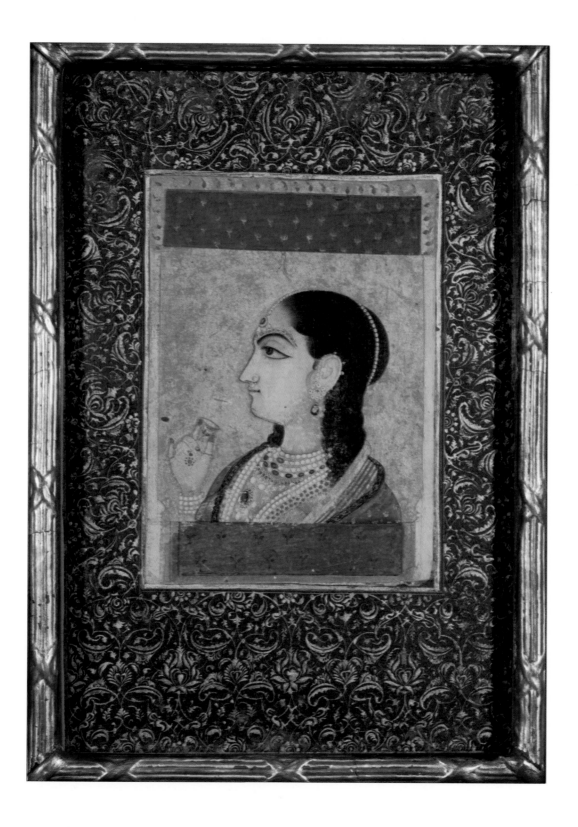

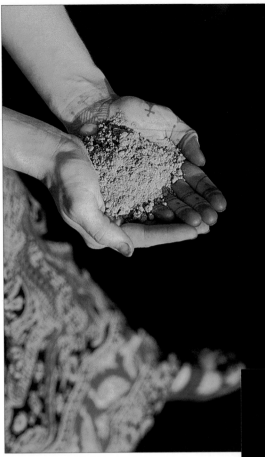
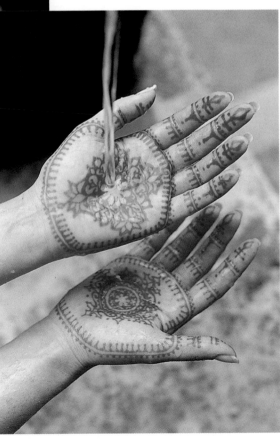

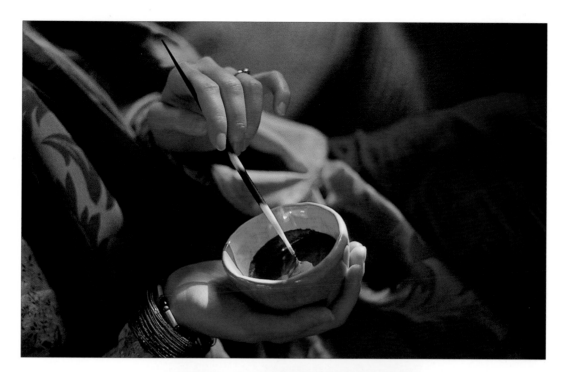
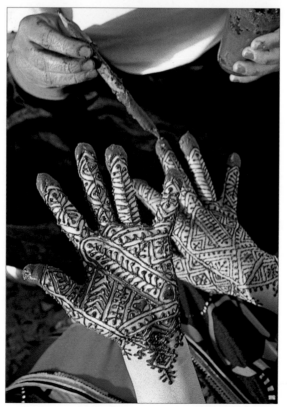

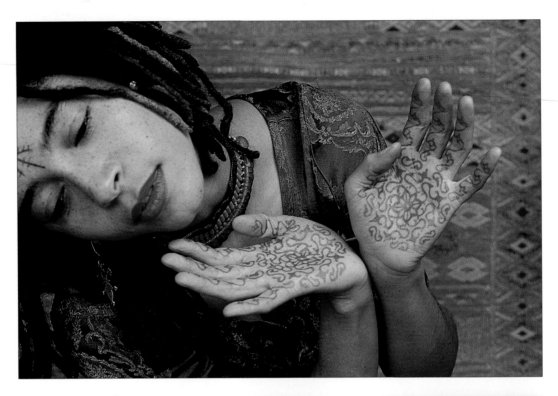

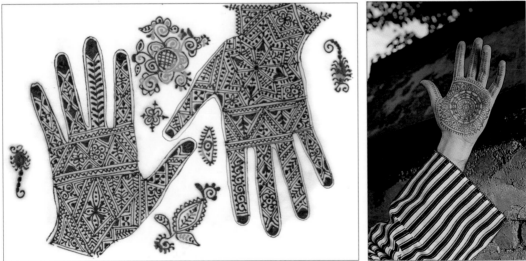

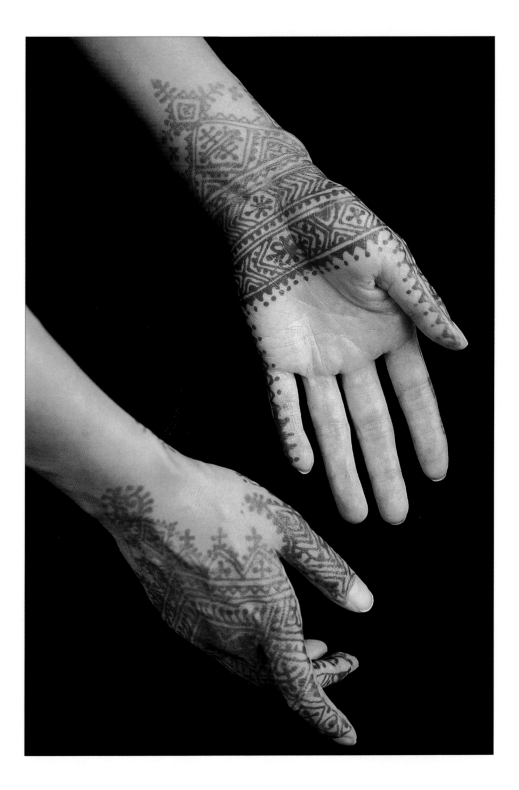

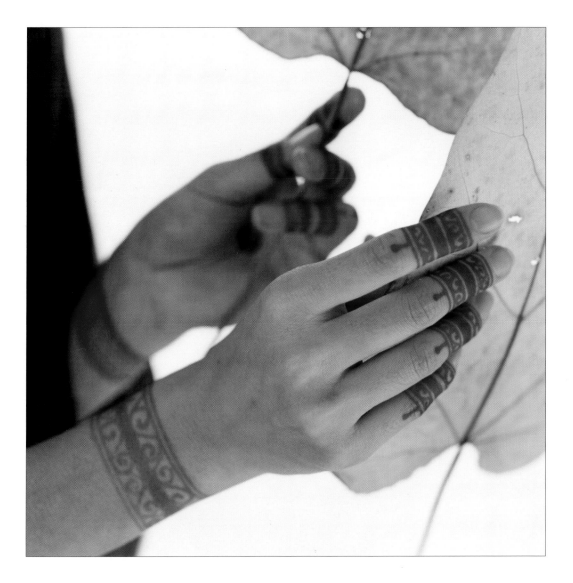

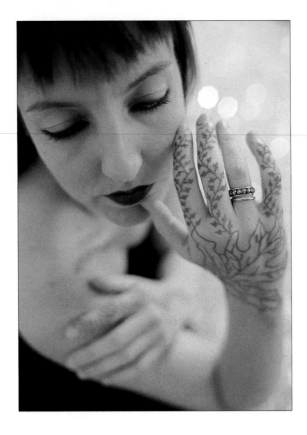

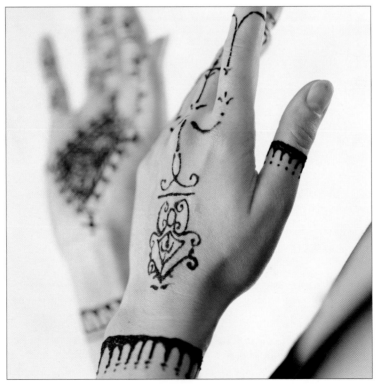

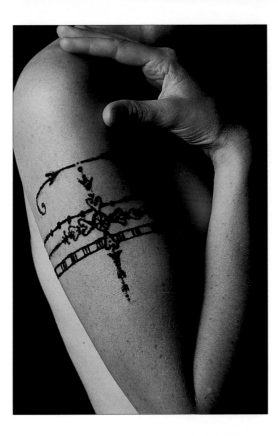
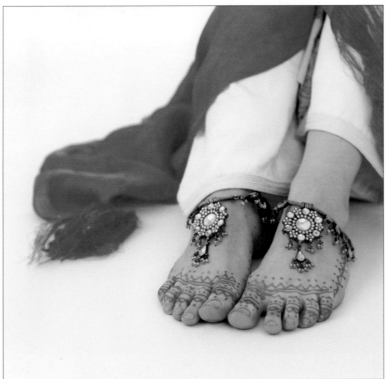

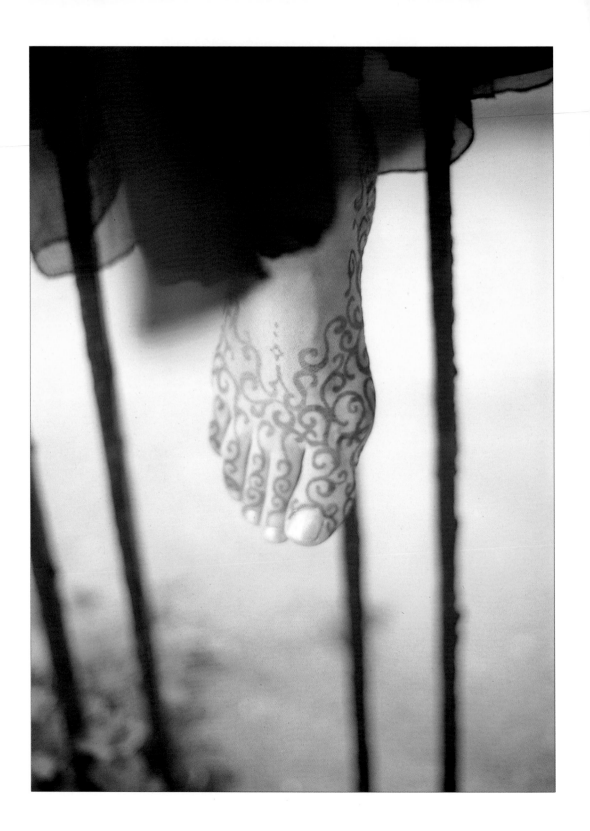

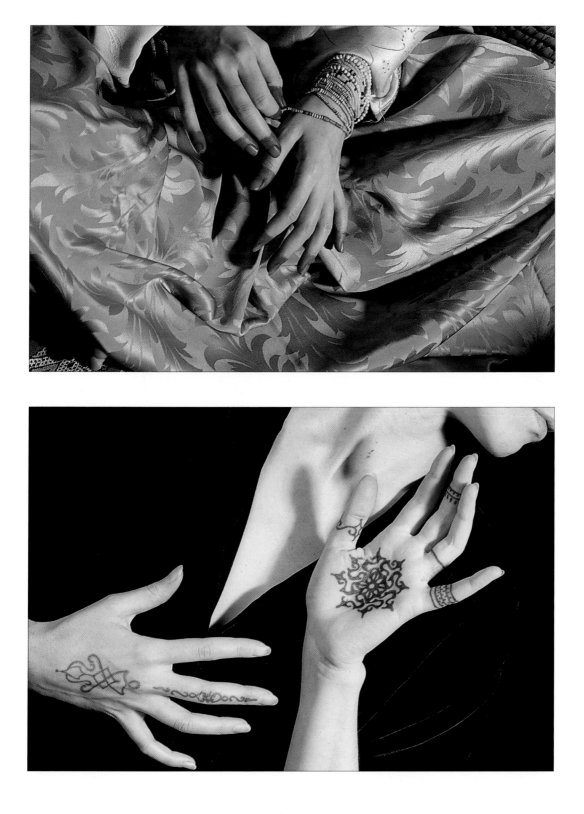

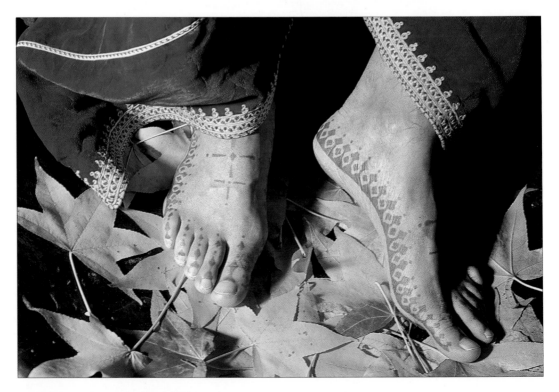

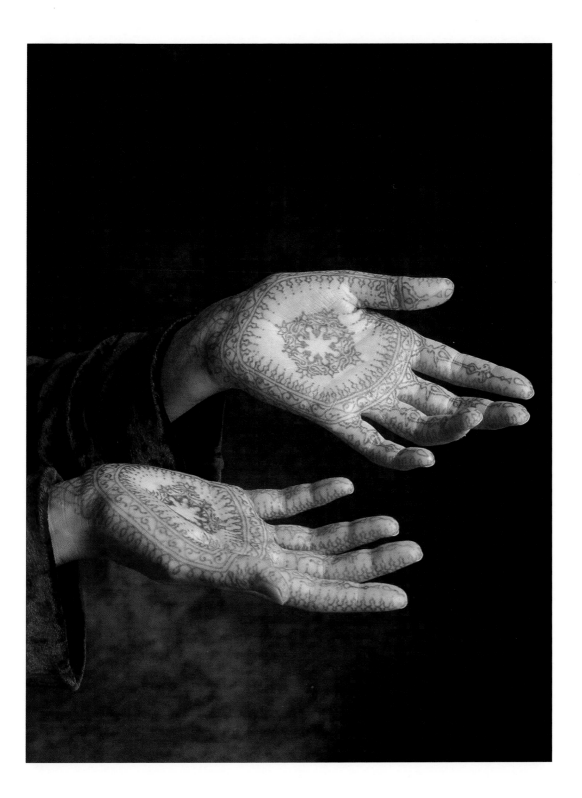

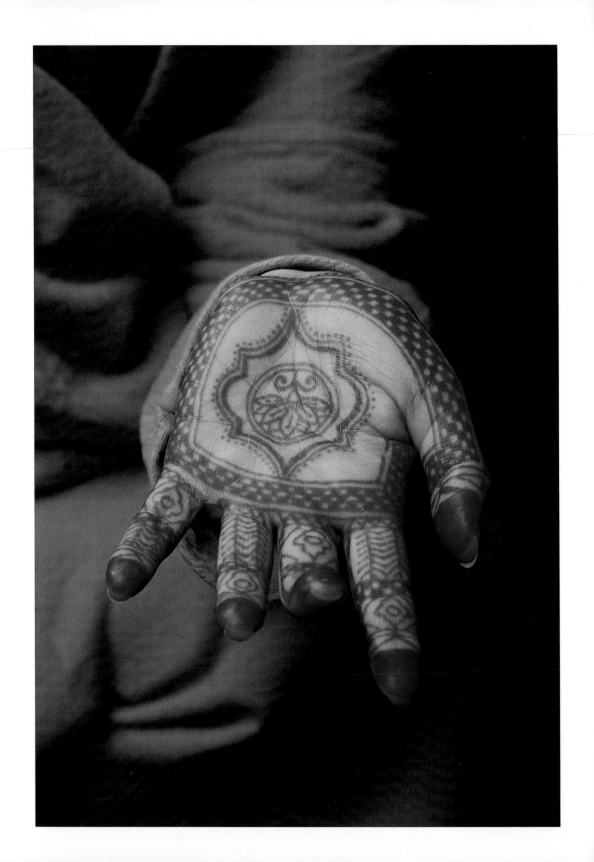

CHAPTER SIX

Recipes and Instructions

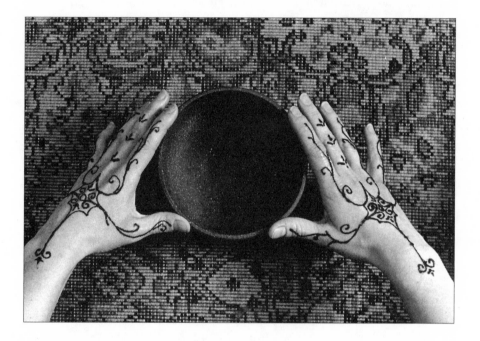

*Asking a woman for her recipe for henna is like asking a
woman her age; you're never going to get a straight answer.*
—LEIGH BROWN, PAINTER
AND HENNA ARTIST

Henna-making is as personal as cooking or baking. The color and quality
of mehndi paste can vary dramatically according to a woman's technique.
Because the depth of color of henna is traditionally equated with the love
that a husband feels for his wife, it's not surprising that a good recipe is
often a point of pride. Learning the art of making a fine henna paste in-
volves patience, practice, and experimentation. There is no one right way.

BASICS

The two essential ingredients in this recipe are henna and water. If you are working with top-quality henna, this combination is all that you need. Of course, the henna must be well sifted and the water the right temperature, but just mixing water with a strong henna can give you a nice deep color. Unfortunately, not all henna is this fresh, and even water can be a problem if you're using it from the tap. (Using bottled water or rainwater is the better option.) Luckily, there are some other ways to help the process along.

Two important factors to mention before we begin are temperature and timing. Henna needs to set, much the way a loaf of bread needs to rise. If you try to use it before it's ready, you will not get the best results. Like bread, henna also requires warmth. This cannot be stressed enough. Generally, the paste will be most effective six hours after being mixed, but only if it is kept at the proper temperature during this time.

PREPARING THE HENNA POWDER

If you have purchased henna that is unsifted, sifting is your first step. If you have purchased a product that claims to be already sifted, be suspicious, and find out for yourself. The easiest way to do this is to mix a small amount of paste, using just water. Then fill one Jacquard bottle, and see if the mixture will pass easily through a .05 centimeter tip. If there's any clogging, you will have to resift the powder.

Henna powder must be stored in an airtight container, just like a flour or spice, and kept away from sunlight. You can use plastic bags, glass jars, or plastic containers. Proper storage is crucial. Heavy-duty zip-lock bags allow you to easily squeeze out all excess air before sealing the bag shut.

GETTING A HEAD START

There are several tasks involved in making henna that need to be done well in advance. Some recipes call for the use of dried limes, which need to be left out in the sun for several days. Sometimes dried lemons or limes can be purchased from specialty stores, but I recommend drying your own. You can do this by slicing the lime to quicken the process or leaving it whole, which can take a number of weeks.

Tea water is another essential ingredient in many henna recipes. The night before you intend to make the paste is a good time to prepare the tea. Moroccans believe that leaving the tea to steep overnight helps to increase its potency.

Of course, you may want to add other things at this point. Experiment, and see what works best for you. Different ingredients alter the color in subtle ways. Only by trying different methods can you find the combination that suits you best.

THE BREW

Start with a good half cup of dark tea leaves in about four cups of water. Boil until at least half of the water is gone. (You can still add more water and repeat this process if necessary.) To this strong tea, a variety of ingredients may be added. I always begin with a handful of cloves (powdered cloves may be used but are much harder to strain from the water), and dried limes or lemons. Occasionally I will add dried pomegranates, red onion skins, black walnut hulls, cardamom (black or green), fenugreek seeds, paprika, turmeric, or saffron. Other ingredients that can be added to this mixture include instant coffee, beet juice, berry juice, pomegranate concentrate, or tamarind concentrate.

Henna artist Stephanie Rudloe taught me to add rose petals to the tea water. Red roses will impart a red color to the mixture, but petals from any fragrant rose (dried or fresh) will scent the brew, and later, the paste. (Moroccan rose petals are ideal for this purpose.) Tamarind is another in-gredient that I add to the tea. (Some people believe that it's best to add tamarind fruit to the tea water after it is removed from the heat, while others feel that cooking it helps to release a darker color.) Adding it last seems to be an effective compromise. Break off a dollar-sized strip from the package, and add it to the brew. Using a spoon, try to break up the fruit as it heats and softens.

Then cover the pot, and let it simmer before leaving it to cool overnight. Don't remove the tea leaves or any ingredients until the next day when you are ready to use the mixture. Don't hesitate to add more water to the brew if it seems to be getting too thick. You can freeze whatever you don't use and save it for another day.

MORDANTS: THE KEY TO A DEEP AND LASTING COLOR

A *mordant* is a substance used in dyeing to fix the coloring matter. Often it is the mordant that determines the intensity and longevity of the color and whether the stain will go deep red or black.

A wide variety of substances are used as mordants in mehndi, not all of them good for the skin. Citric acid (from lemons or limes) is the most common mordant used in this art; however, anything from turpentine to yak urine may be used as a mordant, so be discerning when considering different recipes or choosing to have henna done.

Essential oils are terrific mordants for henna painting, but even these should be used with discretion and care. They are potent substances that

can be harmful if used improperly. It is important to familiarize oneself with all precautionary information by reading labels and instructions. For instance, warnings are made to pregnant women or people suffering from epilepsy to avoid certain oils.

Clove and eucalyptus oil are commonly used in mehndi. Both are semitoxic oils that may become toxic to someone who uses them frequently. Clove oil may irritate the skin.

I abandoned clove oil when my use of it caused a lovely woman named Owna (who I later learned had a history of allergic reactions to other oils) to develop a terrible rash on her hand. I have never used it since. I do use eucalyptus oil in my recipe and have had only positive results. (Check the Resource Guide for more information on oils.)

The most obvious solution for people who want to avoid these risks altogether is to stick to the use of lemons and limes. The other option is careful and proper research and testing of any of the wide variety of alternatives.

Here is a list of substances used as mordants to beware of: gasoline, kerosene, lighter fluid, nail polish remover, paint thinner, turpentine, ammonia, lime, urea (urine), and most commonly, a specialty item sold in Indian and Middle Eastern stores known as mehlabiya oil or mehndi oil, which can vary tremendously in quality.

Other additives to beware of include India ink, food colorings, and hair dyes. Remember, the skin is a living organ of the body and cannot tolerate many substances commonly used on the hair and the nails.

MAKING THE PASTE

Some readers may be frustrated because I do not give specific measurements in this book. Let me explain why I have chosen not to use measurements.

Different types of henna absorb moisture in varying degrees, and getting the proper consistency is based on adding an appropriate amount of fluid to the mixture.

In this section I will focus on a recipe involving approximately one-half cup of henna. This will provide enough henna to create intricate designs on the hands and feet of one person, or simple singular designs like bracelets or central palm designs on more than twenty people. The amount of fluid added to half a cup of henna ranges from two-thirds of a cup to a full cup, depending on the thickness of the brew, the quality of the henna, and the desired consistency of the paste.

When you're ready to make the henna paste, pour the tea water solution from the pot into a bowl without disturbing the sediment of leaves and spices at the bottom. This way, the better part of your brew will pass easily through a filter or strainer. Only after doing this do you want to squeeze out the handfuls of leaves, seeds, and fruit in the mixture.

I was very fortunate that my first teacher, Rani Patel, taught me the importance of always using one's fingers and hands to make contact with the various ingredients. To her each finger represents an elemental power of the universe, and the mixture must be touched by each one.

Once you have squeezed out the tea leaves and tamarind and strained the mixture through a fine sieve, coffee filter, or strainer, you can judge the consistency of the brew. If you have used enough fenugreek or cardamom, the substance may have an almost egg-white-like thickness. If not, you may want to cut up and add one or two okra to one cup of the mixture, allowing them to soak while squeezing their juice into the water. *Bhindi,* or okra (also referred to in India as lady-fingers), gives a saliva-like consistency to the brew and must be strained from the mixture before adding the henna.

At this point, I sometimes add a shot of espresso to the tea water solution, but only after the meat and seeds of the okra have been strained

from it. Add the juice of one fresh lemon, straining the seeds and pulp through a sieve. Then re-heat the mixture, but remove from the stove before boiling. Now you are ready to mix in the henna.

Begin with the henna powder in one bowl, the brew in another bowl, and two plastic spoons. Use one spoon to add the powder to the bowl of liquid while stirring the mixture with the other. When you have reached a thickness similar to that of cake frosting, stir until all lumps and pockets of powder have disappeared.

Moroccan women use their hands to knead the henna paste, slapping it vigorously against the side of a bowl or pot. Often it is placed over coals so that a low, even heat can warm it while it is mixed.

Having stirred it well, add approximately two teaspoons of eucalyptus oil, and then stir. If the mixture has become too liquid, add some more powder to thicken it. Stir until smooth.

GETTING THE RIGHT CONSISTENCY

Test the thickness of the mixture by lifting the spoon a few inches above the bowl. The henna should slowly drop off the spoon, like molasses.

To further test the consistency of your henna, drop a thin line along your wrist or palm, and tap the back of your hand. If the line starts to spread, your henna is too thin. If it will not fall from the spoon, it's too thick. Henna should be the consistency of a thick lotion or warm hot fudge.

When you have reached the proper consistency, let the henna sit in a warm place for at least two hours. During this time, either stir frequently or cover the bowl or container with plastic wrap. (Covering the henna this way sometimes makes it runny, and you may have to compensate by adding more powder.) I find that henna reaches its peak after sit-

ting six hours. Do not refrigerate your henna. This mixture will be good for two to three days. After that, the color will begin to lose its vibrancy.

In *Aesthetics and Rituals in the United Arab Emirates*, Aida Sami Kanafani writes:

> The henna is then covered and left to rest (*tig'od* from *qa'ada* to sit) for a period extending from noon to after the evening prayer *(salat il mahgreb)*. It is usually after the night prayer *(salat il 'isha')* that most women dye their hands and feet. It is believed that the action of the dye is most effi-cacious at night, especially when left on the skin all night. The henna is said to become bashful *(tistiḥi)* from *ḥaya;* timidity, apparently in connec-tion with the color of a blushing face).

MAKING LEMON SUGAR

This recipe is for a mixture of lemon and sugar, used to moisten the henna after it is painted on the skin. This is done by dipping a cotton ball into the solution and dabbing it gently onto the already-dried design. The application of lemon sugar is an essential part of the staining process. This substance acts as a fixative, creating a sugary coating over the pattern that prevents the henna from flaking off. The citric acid fur-ther deepens the color, while the sugar creates a kind of natural shellac. This allows you to use candles, heat lamps, or coals to heat the painted area without drying out the paste in the process.

You should prepare lemon sugar just before you're ready to start paint-ing. When you squeeze the lemon, be sure that you run it through a strainer or sieve before mixing in the sugar. Pieces of lemon pulp can get stuck in the paste, and picking them out is an easy way to disturb a deli-cate design.

The proportion of sugar to lemon varies from artist to artist. I like to add two teaspoons of sugar for every half a lemon. If the lemon is large, I'll add a bit more. (If the person I'm painting is in a hurry, adding a little extra sugar helps to coat the design faster.) Some women insist that you add a teaspoon of sugar for every teaspoon of lemon. I have found that this makes the mixture much too heavy, causing delicate lines to stick to the cotton and be lifted from the skin.

In Morocco, the recipes for making henna paste tend to be simple and straightforward and the recipes for lemon sugar much more elaborate. Jamila El Alaoui taught me to make lemon sugar by adding cloves, fresh ginger, pepper, and freshly minced garlic to the basic recipe. These different ingredients are valued for their ability to create heat, as well as for their stickiness, as is the case with the garlic. The result is a delicious marinade that covers the design with such a sticky coating that the paste will often peel off effortlessly with the cotton if the design is wrapped and left overnight.

TRADITIONAL METHODS

Traditional recipes for making henna require ingredients that are not easy for many of us to find—for instance, henna leaves. I have only been able to purchase henna leaves in powdered form, and some traditional recipes actually call for the use of fresh-plucked leaves. One such recipe from India recommends that the leaves be "macerated in unboiled milk."

Other plant substances, like betel leaves, catechu, or lucerne leaves, are sometimes ground up with the henna to enhance the color. Similarly, fenugreek (or methys seeds) may be ground up with the henna leaves as well. Fresh indigo is sometimes used to give the henna a blueish cast, but the leaves must be fresh. Powdered indigo will not be effective.

In Malaysia, sticky rice is used to give the paste the desired consistency. The use of egg is common in Africa and the Middle East.

Sephardic wedding tradition calls for honey to be poured over the bride's hennaed palm after a gold coin is placed in its center. Her hand is then wrapped in scarves for the duration of the evening before the wedding. This is done to insure prosperity and happiness along with deep and lasting color.

OTHER SIMPLE RECIPES

One recipe used in Africa and Asia involves lemon juice instead of water. The powder is mixed with pure lemon juice, and no other ingredients are added. I have heard that it is best to halve the lemons and leave them in the sun for twelve hours before doing this. Others recommend the addition of eucalyptus oil to this basic recipe.

Another simple recipe calls for adding the henna powder to hot water. There is some controversy over the appropriate temperature of the water. Most tend to agree that boiling the mixture is a mistake, but there are those who insist that it should be hot.

Many recipes use sugar to thicken the actual paste. I have also heard Moroccan women claim that this helps darken the color of the henna. An artist from India or Pakistan will often add lemon sugar to the henna paste, as well as using it separately. One standard recipe combines tea water, lemon, sugar, and clove oil. Other times, a "candy water" will be made by dissolving traditional sweets in water. In Morocco, orange-blossom water will be mixed with sugar to "aromatically subdue any unpleasant odor from the henna plant."

Some recipes are more basic than others. For instance, author Barbara

Siegel Barber writes the following about her experience of being painted in Tunisia:

> Making ample use of saliva, she took a small ball of henna and put it in her mouth, coated it with saliva and shaped it before she put it on me. All the while female relatives and children kept arriving. The women said *saha* to me, which means something like "wear it in good health" and I replied, *yatik saha*, which means "same to you."

A WORD OF ADVICE

Mehndi is an absorbent substance. It takes on the feeling that surrounds it. If you're careless and hurried, if you mix your henna in front of the TV, it will not have the same quality as that of the person who sees this process as an opportunity for meditation or prayer. To make henna into a paste, you draw upon centuries of tradition, and for every pattern you paint, many unseen hands have labored—planting, harvesting, grinding, and sifting. You are the last in a long chain. I recommend taking a moment to contemplate this. Try to be as present as possible in every step of the process. There is much that you can learn about yourself through this medium.

For better or for worse, the henna never lies.

The artistic challenge only appears
to be the task. Skill, style, tech-
nique; these are just the branches,
evidence of a deepening, widening
world beneath the surface.

Application and Care

BEFORE APPLICATION

One of my favorite traditions from Morocco involves washing the skin with rose or orange-blossom water before the painting begins. I have also heard that a lemon or lime is sometimes rubbed into the skin before painting for the dye to yield a deeper color.

Similarly, mustard oil and eucalyptus oil may be used before beginning a design. This method is popular among artists from India, though I consider the eucalyptus to be too strong to use directly on the skin. Most artists feel that the use of oil on the skin before painting is unnecessary. The important thing is to wash the area well in warm water in order to make sure that the skin is free from all lotions, make-up, sunblock, oils, or other cosmetics that may block the pores and create a barrier between the dye and the skin.

APPLYING HENNA TO THE SKIN

This is the fun part.

Painting with henna is similar to decorating a cake. This is because the lines that you create are three-dimensional. The most important detail about

the art of application is NOT TO TOUCH THE IMPLEMENT TO THE SKIN. Henna is traditionally dripped on the skin from a twig or wire or from the fingers. It is done this way to allow the lines, however thin, to lay upon the skin like rope, not flat like a ribbon.

The thickness of the line determines the amount of dye that will penetrate the skin. It is the mark of an inexperienced henna artist when lines are drawn or painted with the tip of a bottle, stick, or brush, and contact is made with the skin. This is because the lines will be thin and flat—and the resulting color unimpressive. Occasionally the artist may develop the ability to drag the tip of a bottle or syringe at such an angle as to leave an undisturbed line. But this requires holding the bottle at an extreme angle nearly parallel to the surface.

This technique may be particularly frustrating for those who have been drawing for years. If you try writing without resting your hand upon the page, it will give you an idea of how strange this feeling can be to someone who has grown accustomed to support and pressure at the point of contact.

Add to this the fact that you are now applying pressure to the sides of the bottle instead of the tip of a brush or pen. Learning to control the flow of henna involves learning to squeeze with appropriate pressure and pull at the appropriate time. This becomes easier with practice, and you will become better and faster over time.

You will also notice that it becomes an effortless task to create very fine lines. The more you practice, the thinner the lines that you will be able to create.

POSITIONING

Begin by positioning yourself and the person being painted. Be sure that both of you are comfortable and well supported by cushions, chairs, or

whatever else serves the purpose. When painting hands, I like to sit next to the person in unupholstered chairs with arms. This allows both of us to have support below the elbow. Always sit on the side of the hand that you are painting—and be sure to switch seats when you begin the other hand. Reaching is a waste of energy for you both.

When sitting on the floor, I will seat the person next to me and rest his or her hand in my lap. Sitting at a table is also an effective method—although sometimes it's easier to sit across a small table and join hands at the center. I prefer to be next to the person I'm painting and not to have a large object, like a table, between us.

When doing foot work, I prefer the person being painted to sit on a high-backed stepstool with one leg crossed over the other. These are the kind of kitchen stools that were common in my grandmother's childhood. They are perfect for doing border work at a comfortable height.

The Moroccan artists I have worked with are skilled at using pillows to position their clients' hands and feet. Moroccan throw pillows are perfect for this task because they come in a variety of slender rectangular shapes. They are firm, textile-covered pillows ideal for resting in your lap or across a low table. They can be used to support a client's ankle, arm, hand, or foot. (Check the Resource Guide for information about where you can purchase these.)

When positioning yourself and the person you're working with, be sure to consider the task. Are you painting both sides of the palm? Will one side be more intricate than the other? This will determine how you begin and how you choose to position the person's body.

For intricate work on both sides of the hand, I recommend the use of a table. In traditional henna work, you often begin at the top of the middle finger and work your way down to the wrist, spreading gradually to the other side of the hand. I prefer to cover the palm, leaving the fingers bare. I then ask my client to turn his or her hand over and rest the finger-

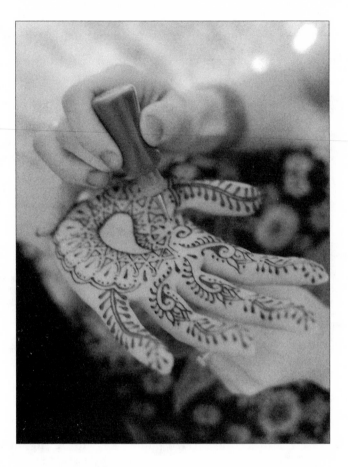

tips on the edge of the table—with the elbow still on the arm of the chair. This way we both have support for the elaborate work to be done on the top of the hand. Otherwise, you will both battle shakiness and fatigue. It is always worth taking the extra moment to consider the design that you're about to do and find the most supported way to position your bodies.

TOOLS AND TIPS

Having the right tools to work with is essential in any medium. I feel quite confident saying that the Jacquard dye bottle is by far the best

product available on the market for this kind of work. Of course, a cone is still a superior tool for henna work, but I find that it takes a great deal of practice to become comfortable with this technique.

If you are interested in doing professional work as a henna painter, I suggest that you make the effort to learn to use a cone. This is primarily to protect your hand from repetitive stress injuries. The Jacquard bottle is much harder to squeeze and can cause severe cramping in the hand if you're doing mehndi for several hours a day. The cone can also get an even finer line than the .05 centimeter tip will give you, although clogging tends to be less frequent with the metal tips.

Other means of applying henna include the following: a matchstick, needle, toothpick, or twig; a bit of wire (silver or gold if the person is rich); the wicker of a broom; the tube of an empty pen; a syringe or hypodermic needle used in veterinary medicine (with a large needle, which is then cut); a porcupine quill, skewer, knitting needle, or khol stick (often made from ivory or sandalwood); a pastry bag (watch out, they're porous and will stain your hands); a plastic bag (with a hole in it); a calligraphy pen, feather, or fish bone.

Perhaps most fascinating to me is the traditional method of creating spider-thin lines by dripping henna from between two fingers instead of using an applicator. This is done by pressing the thumb and index finger together and then pulling them apart in order to create thin threads of paste, which are then laid into place. The use of fenugreek, cardamom, gum, sugar, or okra gives mehndi the saliva-like consistency that makes such application possible. This is the most traditional method of application in India and one rarely practiced by younger artists, who have grown up with materials unavailable only decades ago.

In mehndi, there are several tools that complement the bottle or cone used as an applicator. One of these is a porcupine quill. I have heard that these were sometimes used as applicators in North Africa, but I prefer to

use them to do clean-up and corrections. Flat toothpicks are the next best thing, but the wood is often porous and splintered, and I find that I can go through a tremendous number of toothpicks in a single sitting. Pointed objects like pins, regular toothpicks, needles, or thin wire do not provide the flat edge necessary to shift and redirect a line of henna. The porcupine quill is sharp and thin-tipped at one end, making it a useful tool for lifting bits of thread (from lemon-sugared cotton) out of the drying paste and for mending minute imperfections in the design. The other side of a porcupine quill is wide and tapered, making it ideal for straightening lines and for reworking larger areas where spreading or poor placement force one to work quickly.

Other helpful tools include cotton swabs, cosmetic make-up applicators, or even a bit of tissue wrapped around the end of a toothpick. Anything that can help to lift the paste up fast in the event of a mistake or accident. If the henna is at peak intensity, you will have very little room for error. Even thirty seconds is enough time to leave a stain. Normally you can get away with making minor adjustments before the henna dries. Use a dampened cotton swab to wipe the area after removing the paste. Remember, the color of the stain deepens for a good twenty-four hours after the paste is removed, and that includes the mistakes, though they may be pale in comparison to the rest of a design.

In true mehndi, error and innovation go hand in hand. Mistakes don't exist, only variations, and these define the unique character of each individual design. So, as a rule, don't try to fix it, just work it in.

HELPFUL HINTS

Rings, bracelets, arm bands, and ankle bracelets all follow the same principles of application. If you're doing a bracelet, start at the center of the top or the inside of the wrist. You can start on either side; just make sure you're

perfectly centered. Once you've drawn the band or line across, begin slowly to extend the design down around the sides of the wrist, on either side. The thumb side of the wrist is usually very easy. But the skin twists on the other side if someone is turning an arm to accommodate your reach. Ask the person instead to lift his or her hand as if taking an oath. When you have painted enough so that a bit of design is visible on both sides when you turn the wrist over, you are ready to complete the bracelet.

The most important thing about designs for places other than the hands and feet is that they must be thick. Bold patterns work better. You can still do graceful designs, but you can't use very thin lines because you need a thick layer of henna in order to produce a decent color.

Never lift someone's arm or leg in order to see around a vanishing horizon. If you're doing an arm band, turn the person to face you or face away from you. This technique makes it possible to do full arm bands without straining in awkward and uncomfortable positions.

After much trial and error, the best way I've found to deal with painting the soles of the feet is to just scrape the paste off after a couple of hours.

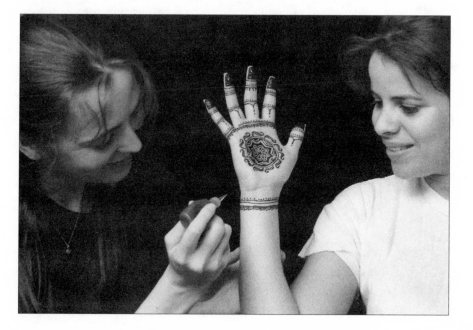

You'll still get a very rich color. If someone tries to walk around, or sleep without his or her heels elevated, the mud will spread and ruin the design.

Whenever you use a thick layer of paste, for example when dipping fingertips or covering the sole of the foot, be sure to monitor the color unless you want the stain to go black. Often, two hours will be enough time to stain the skin a deep red.

DIFFERENT TECHNIQUES

There are a variety of unusual methods used to create dynamic henna designs. Many of these are traditional practices. The batik method is popular in India and is done with a white, paintlike paste made from thick lime used in eating betel leaf. This is painted on with a hard brush and then allowed to dry. The designs are then covered with henna and left to stain for several hours. The effect is white designs on a red background.

FACING PAGE: After the henna is applied to a hand or foot, it is baked onto the skin over the heat from aromatic coals. When all the limbs have been decorated, the clay-like paste is covered with cotton and each hand and foot is wrapped in scarves, to protect the henna from crumbling while the woman sleeps. Ideally, the henna must be applied twice, on consecutive days, for the design to be clear and bold. Thus, on the second morning, the paste will be scraped off, breakfast will be served, and the entire process will be repeated. The longer the henna remains on the skin, the deeper and more permanent the color.

—MARIA MESSINA,
FROM "HENNA PARTY"

Other batik methods include dripping patterns in wax onto the hands and allowing them to cool before smearing henna on the skin.

In Asia as well as many countries in the Middle East, henna patterns are sometimes embellished with other pigments or paints. This technique is most common for the feet. In India, small white dots of paint beautifully accentuate the border of a deep red design; whereas in the United Arab Emirates, a black substance called *snajer*, taken from the pod of a plant, is used in a similar fashion.

Of course the use of stencils is a popular technique. I have seen some lovely stencils from India, but I have heard that the adhesive can irritate the skin.

One of my favorite techniques in henna painting, which has

not been explored enough, is the method of using a variation of strengths in color (for example, scraping areas at different hours to create variations in tone).

This can also be done by reapplying henna to faded areas. The result is a palette ranging from black to pale orange, which gives the artist the flexibility to do detailed rendering as well as two or three-toned work. This kind of technique was used to create the design on page vi.

APPLICATION OF LEMON SUGAR

LEMON SUGAR MUST BE APPLIED AS SOON AS THE HENNA HAS DRIED. This is a crucial step in the henna painting process. To apply lemon sugar, dip a cotton ball into the solution and gently dab it over the entire design. This must be done *only after* the henna has dried.

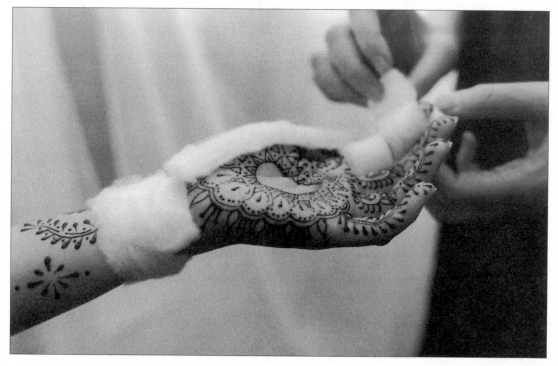

There is actually a perfect moment for applying lemon sugar to the design. It is the instant that the surface of the paste is entirely dry. Mehndi takes anywhere from three minutes to half an hour to dry on the skin, depending on the climate and the thickness of the lines. You can tell when the henna is dry enough because the paste takes on a matte instead of a shiny finish. The lines will be firm, but the paste will still be moist, and thicker areas may still be a little soft in the center. It is important to use a light touch so as not to flatten thicker areas, especially in patterns where lines overlap or intersect. Do not wait until the henna has started to crack and flake.

When applying the lemon sugar, take care not to allow the cotton ball to become too saturated. It should be placed in a small dish or plate next to the bowl and squeezed from the back when it is reused. This releases the excess fluid without flattening the top. As silly as it sounds, the cotton ball must remain fluffy and light where it comes in contact with the design. This means that it must be replaced from time to time and that it must not be dropped into the lemon sugar bowl, as is likely to happen.

ALWAYS USE 100 PERCENT COTTON BALLS. Synthetic cotton balls dissolve into a mess of intrusive fibers that get stuck in the henna and often grab onto each other, lifting the design from the skin when you attempt to reapply the solution. Beware of bags marked "cosmetic puffs." Remember, the imitations are designed to look like the real thing.

Never apply so much lemon sugar that it pools or drips. This will either loosen the henna from the skin, or cause the dye to spread and smear. You will never get a clear, crisp line if you apply lemon sugar incorrectly.

One traditional method of lemon sugar application involves halving a lemon, squeezing it just enough to bring the juice to the surface, and then dipping it into a small dish of sugar before touching it lightly to the design. It may be wise to use confectioner's sugar if attempting this approach. Be sure not to pick up too much sugar before touching it to the skin.

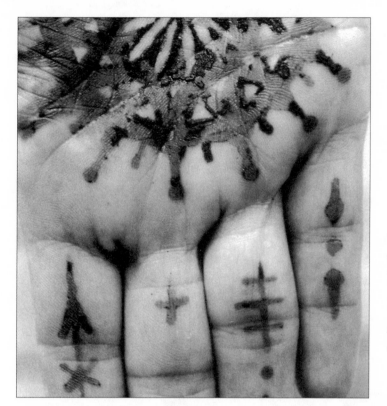

After applying mehndi, one should not go astray in fore-noon or afternoon, and walk through crossings of two roads or go under a pipal imali (tamarind) tree, because then the evil spirits supposed to be roaming about such places get a chance to take hold of their victims.

—JOGENDRA SAKSENA,
FROM *ART OF RAJASTHAN*

I recommend waiting until after the first couple of applications of lemon sugar to apply external heat. Otherwise the henna can dry out and crack. (Some cracking is natural and occurs as the henna dries and contracts.) Lemon sugar should continue to be applied throughout the course of an evening at intervals ranging from ten minutes to an hour. You know that it is time to stop when the sugar creates an impenetrable candy glaze. At that point, the solution is no longer affecting the paste. In fact, if you successfully bake the lemon sugar into the paste by applying heat, I have even heard that it's possible to dip one's hand into a plate of water and remove the sugar glaze in order to start the process again. The young man who told me this had on his palm some of the darkest color that I've ever seen.

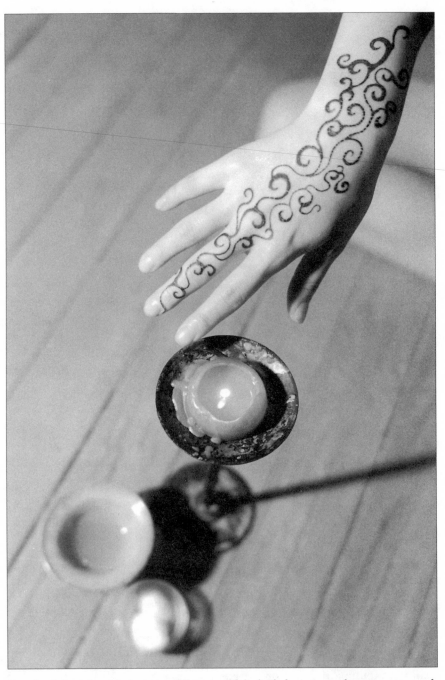

In each painting is found the beginning of the next, and the finished painting is a beginning, not an end.
—VALERIO ADAMI,
FROM *A LIFE IN THE ARTS*

106

HOW TO CARE FOR YOUR HENNA DESIGN

Caring for your design after the paste is applied plays a crucial role in determining the outcome of the work. In this sense, the artist and the person being painted are collaborators. Proper care involves both diligence and patience. This requires maintaining a warm skin temperature, applying lemon sugar, and, most importantly, giving each step of the process sufficient time.

The longer the henna remains on the skin, the more the color will deepen. Color also depends on temperature. The more heat is applied to or generated by the body, the darker and more lasting the color will be.

Sudanese henna is known for its dark color. Although this is often due to the use of harmful additives such as ammonia, this darkness may be attributed in part to Sudanese customs of care. I have heard that Sudanese designs are cured by the smoke of a particular wood. A hole is dug in the desert floor in which a fire is built, and the bride is made to sit by it, under a wool blanket. Aspirin water is rubbed into her skin by an attending woman who reaches up under the blanket. The bride remains there as long as she can stand the heat.

My suggestions are far less extreme. I tell people to have a cup of hot tea and heat their hands over a candle or lamp. The important thing to realize is that henna draws heat from the body. The temperature of a hand painted with henna will be noticeably colder than the unpainted hand. Begin by keeping the room warm. Do not open the window or turn on an air conditioner or fan. The higher the temperature, the better.

Heat can be applied to henna designs in a variety of ways. In Morocco, a coal brazier is used to warm the hands and the feet while the henna sets. In India, the hands are held over a handful of cloves heated in a dry pan. These appear to crystallize while turning to ash.

I use candles and single coals, which are easy to take along to a party

or event. Often I will add a few cloves and a bit of incense to the top of the coal, which can sit on a small stone or metal plate. Barely touching a match to its surface will cause a wave of little sparks to bubble over the surface of the coal, which will then begin to burn. (It will smoke for a moment, and then subside.) One small coal lasts more than an hour.

A gooseneck lamp makes a terrific heating device, as you can easily aim it in a variety of directions to warm the hands or feet. If you want to treat yourself to a nice deep color, buy a bulb used for a heat lamp (the same kind that is used in a restaurant to warm food or in a terrarium). If the lamp you have is not compatible, a basic heat lamp is inexpensive and can clamp on to the edge of a table or the leg of a chair. You can find these at most pet shops or hardware stores.

One client wrapped her belly design in cotton, covered it with plastic wrap, and then placed a heating pad on top of her stomach. Others use blow dryers, though they tend to cause the paste to dry out and flake off. When using powerful heating devices, you can use plastic wrap or plastic bags to keep patterns from drying out by trapping moisture beneath the plastic. However, this has its drawbacks, because designs can sometimes spread, slide, and smear. It's important to use cotton and tissue beneath the plastic wrap in order to be sure that excess moisture is absorbed.

WRAPPING

Wrapping a mehndi design is a delicate process. First you must unroll balls of cotton into strips. Jamila El Alaoui showed me this trick. The average cotton ball is actually a small roll of cotton, between four and six inches long. You can unroll these easily. Then you can lay them over the design, making sure to cover the entire area (for instance, in between the fingers and at the very top of the fingertip). I find that wrapping the de-

sign in toilet paper or gauze is helpful after wrapping it in cotton. It keeps everything snug and in place. Some women put a knee-high nylon directly over the cotton. A kitchen mitt, athletic sock, or anything like that will help keep the hand open, flat, and protected.

SCRAPING

Scraping off the paste instead of washing it off helps the color to take more deeply. Generally speaking, you should scrape a design first thing in the morning. To do this, use a blunt or plastic knife. Sometimes the cotton will stick to the paste and lift the entire pattern right off the skin. At other times, it can be a difficult task to remove the paste. Use a little mustard oil if you feel yourself starting to scrape too hard.

Don't cheat by rinsing. Use oil (sesame or olive oil if you have no mustard oil) to gently massage the bits of dried henna from your skin. Only after you've scraped all of the paste off and cleaned the residue with a cotton ball dipped in mustard oil can you think about wiping the area with water. I do this with a dampened cotton ball or swab, focusing on the negative space between lines of color.

Reapply oil after this step. It is best to keep your body out of water for a full twelve hours after scraping. Henna metamorphosizes for twelve to forty-eight hours after the paste is removed. This is another magical step of the process. The color will deepen to sometimes two or three times the intensity of its original appearance.

On some parts of the body, it can take a long time for the color to come up, and the design may not really appear for several days. It's one of the mysteries of henna. The palms and soles of the feet generally reach their peak color within twelve to twenty-four hours after the paste is removed.

To care for your design, stay away from soaps and harsh detergents.

Using gloves to do the dishes and washing with soap only when you need to will greatly extend the life of your design. To brighten a fading design, rub a little mustard oil and lime into the area. I have seen henna last up to six weeks with proper attention and care.

REAPPLICATION AS A DEEPENING METHOD

Some people use henna as an alternative to tattooing and want a really lasting design. Reapplication is a simple way to extend the life of your design indefinitely. Touching up a design once a week creates the illusion of permanence and is a safe and satisfying option for many people, especially parents. It's very easy to make a henna tattoo appear permanent, while still giving yourself the option of choice and change.

I recommend freezing a few bottles of henna when making the paste. This allows you to retouch a design several times without bothering to make a fresh batch. If you've hennaed your nails, you may want to reapply more as they grow out, to keep deepening the color.

Patterns Made Simple

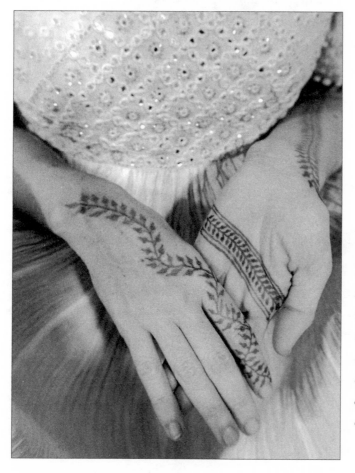

The artistic process is more than a collection of crafted things; it is more than the process of creating those things. It is a chance to encounter dimensions of our inner being, and to discover deep, rewarding patterns of meaning.

—PETER LONDON,
FROM *A LIFE IN THE ARTS*

Much of the allure of henna painting comes from the compelling nature of repeated form. Patterns are based on repetition but not limited by it, just as individuals are variations on the human motif. I am the same as you but different as well.

Mathematics reveals a hidden beauty and simplicity in nature. Out of

a single equation comes infinite possibility. You can know the formula without ever knowing the outcome.

One of the most wonderful things about being a henna painter is experiencing this limitlessness. You become skilled at letting go of what you think should happen, allowing the design to tell you where to go. You develop a certainty and confidence in your skill, and at the same time, a deepening sense of freedom and possibility—a sense that with each beginning you stand before the unknown, waiting for a pattern to unfold.

BEGINNING A DESIGN

One of my favorite tools in henna painting is the coin. I have a small box of coins of many shapes and sizes that I frequently use to begin my designs. The coin has two functions that make it an effective starting tool: centering and circling. There's nothing worse than spending hours painting a design only to realize that it is not properly centered. This can happen all too easily. By using a coin to start the design, you can experiment with placement before you begin.

Sometimes the simplest forms are the hardest to execute, because any hesitation or error is going to be visible. This is most true of the circle. The circle is one of my favorite symbols, and I use it all the time. But if I'm having a bad day, my circle can easily look like an egg, or be shaky and full of doubt.

Using a coin is one of the most effective ways to give yourself a strong foundation while working with a circular motif. I use an Egyptian coin slightly smaller than a quarter to begin most mandala designs. By tracing a circle around the coin, an eighth of an inch from the edge, it becomes easy (with practice) to lift the coin away without disturbing the henna. Another effective method is to press the coin gently into the per-

son's skin for ten to fifteen seconds. You can then paint directly over the impression left by the coin.

Now concentric circles may be added by running another line along the outside or the inside of the initial circle. Always work out or in from the existing line; in other words, don't immediately start working in the center of the circle. Work your way in.

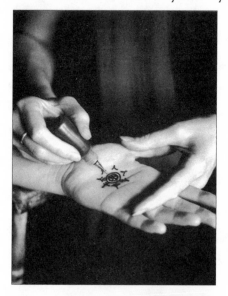 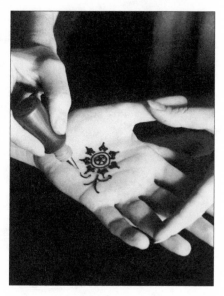

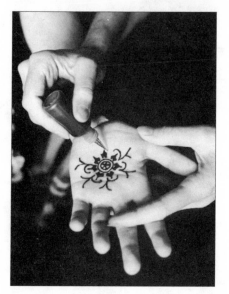

By working systematically from the center outward, a complicated mandala design emerges from a series of simple steps.

Coins can serve many other functions as well. I use coins to begin many different designs: diamonds, stars, flowers, crosses, hexagons, and paisleys, to name a few. A coin with a star (mine is from Cuba) is a perfect tool for marking off the points of a star design to make sure they are all equidistant. A coin with a cross (I have one from Sweden) makes it possible to mark off the points of a diamond, X, or square as well as a cross or straight line. A coin with a hole in the middle can allow you to mark the center point of a circle, and a coin with fluted edges can help to insure that the many petals of a flower are evenly placed.

You can find old or foreign coins in most flea markets or antique shops. Ask friends and family to collect unusual coins when they're traveling—each one opens a new door.

CENTRAL PALM DESIGNS

Central palm designs are the most satisfying patterns to do and to see done. This is because the palm is the ideal surface for mehndi. Not only does it get the deepest color, but it creates a lovely frame around a central image. It is my personal preference, after studying and creating many designs, to leave a little breathing space around the central motif. The use of negative space is crucial in intricate designs. Otherwise, details tend to get lost and blend into a glove-like mass.

(a)

THE MANDALA

The mandala is a revelation of possibility. As a central palm design, its center forms a perfect bija, or matrix, for the entire hand. The better you get at doing mandalas, the more compelling and interest-

DIAGRAM 1

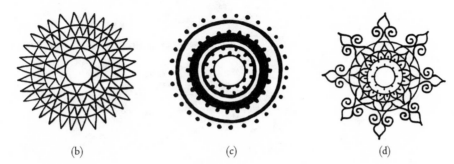

(b) (c) (d)

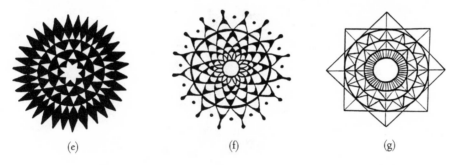

(e) (f) (g)

ing the patterns become. If you work with this one central form for any length of time, you begin to sense the nature of infinity. Where you perceive a limit, it is in your own thinking. There is literally an endless number of designs you can create within a given form.

Let's begin with four concentric circles (Diagram 1a). After centering the pattern with a coin and adding the three additional circles, the next step is to decide the basic style of the form. Will it be delicate, bold, graceful, strong, geometric, simple, intricate, or just whatever it becomes?

Let's say that you want to do something similar to Diagram 1b. Diagram 1b begins in much the same way as Diagrams 1c, d, and g. The first step in most cases is to mark off the primary points. I always start with a tiny dot at 12:00, 3:00, 6:00, and 9:00. Subdivide these sections once or twice depending on the nature of the design, but understand that

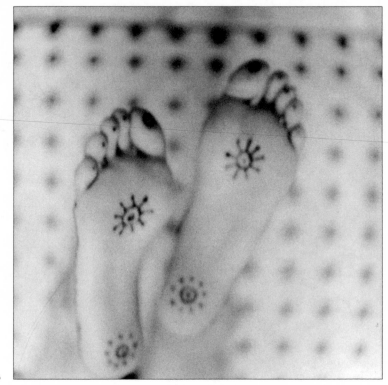

if you ignore this step as a beginner, chances are that your petals, trian-
gles, spokes, or spirals are going to run amok and will probably end up
misshapen or imbalanced. Even if you have a good rhythm in rounding
the circle, joining it up will be hit or miss. This technique is important
because it trains your eye to look at the whole instead of getting sucked
into the intricacies of the design. Remember, 12:00 can be wherever you
put it, even if you prefer not to see it at all. Perhaps you are making a
seven-pointed star. You can still use your imaginary clock to help estab-
lish the primary points (see clock examples in Diagram 4).

Intricate designs are an irresistible challenge for the henna artist, and
contrary to popular opinion, they are not as hard as they look. Intricacy
does involve one crucial ingredient: patience. The most important advice
I can give you is to have the patience to let one line stiffen and nearly dry

before joining it or crossing it with another line. Look at the outer circle in Diagram 1f. What appears to be a complicated pattern is merely a simple overlapping form. The key is to allow the first lines to dry enough before adding others on top of it.

Similarly, the artist must use patience and discretion when filling in lines with solid color. This technique is a thrilling part of henna paint- ing and can completely transform a design in just minutes (see Diagrams 1b and 1e). The important thing is to wait for the right mo- ment to do it. If you attempt to fill in lines that have not yet dried, the henna will spread, and you will lose all the crisp definition that brings the pattern to life. Still, this is a temptation that we can all fall prey to, even after years of experience. It is easy to become excited and impa- tient, especially if it's a damp day and the lines take a while to stiffen. Just give them a couple of minutes before you proceed. Believe me, it's worth the wait.

Depending on which areas you choose to fill in, you can create a myriad of different designs from a single pattern. Experimenting with this technique is lots of fun and a great way to finish a session. Just when the person you're painting thinks he or she knows how the de- sign will look, you can transform it completely. There is no limit to the number of options that this technique gives you with a particular pattern.

DIAGRAM 2

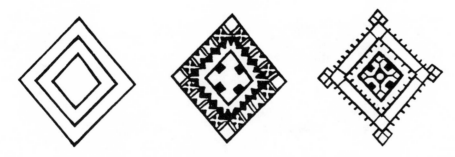

FLOWERS AND STARS

Diagram 3a creates the foundation for countless designs. My favorite is the eight-pointed star, or ashtadala. Begin with a plus sign, and then add two diagonal lines, forming another perfect plus sign. Now, imagining a circle well outside of the pattern, mark off the tip of each star (or petal, if you're doing a flower) with a small dot. (See Diagram 3d.)

DIAGRAM 3

Beginning with simple lines and dots helps your designs stay symmetrical. Many different designs share the same first steps.

DIAGRAM 3 (continued)

You can create a variation of this motif by extending parallel lines out-ward from the central form so that all edges of the star are parallel to the lines bisecting the central point. (See Diagrams 3i–k.) The effect this produces is that of the tails of four arrows meeting at a center point. This can be used as the basis for many other designs.

Flowers with eight petals are created by softening the lines with a slight curve. (See Diagram 4d.) Flowers with six petals can be made by placing an X over a line, like an asterisk, and applying the same formula. Another effective way of creating flowers involves starting with a small circle and marking off the appropriate points. (See Diagram 4a and 4c.) For an eight-petaled flower, 12, 3, 6, 9, 1:30, 4:30, 7:30, and 10:30. For a six-petaled flower, 12, 6, 2, 4, 8, 10. After this, all the same rules apply.

DIAGRAM 4

This technique of marking the appropriate points on a circle becomes very important if you're attempting more complicated flower, star, or sun designs such as that in Diagram 1f. In this case, the only hope for success lies in first marking the appropriate spots of the cross, 12:00–6:00, 3:00–9:00, and then bisect and bisect again. Use tiny dots just at the inner edge of the outer circle. Then you mark off the outer rim of the inner circle and start to connect the appropriate points between the two. It's much harder to describe than to actually do, and you will be surprised by how much easier a complicated pattern becomes.

Here a pattern of connecting spirals creates a simple and elegant border for the foot.

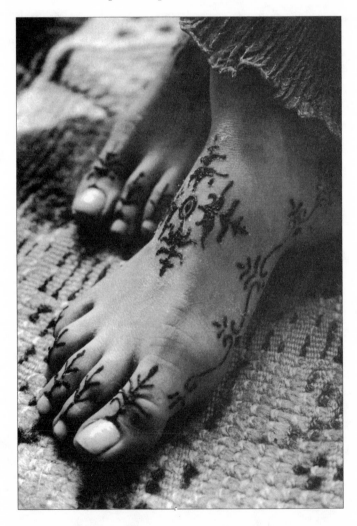

I often talk about "breaking a pattern." By this I mean figuring out a simple and clear-cut way to approach it—decoding it, so to speak. Most complex patterns have a very simple formula at their root. Take this pattern, for instance:

DIAGRAM 5

(a)

At first glance it might look difficult, but it couldn't be simpler to paint. Begin with a series of connecting ovals. Then divide each oval by adding an arch on all four sides, or, if you prefer, a curved diamond to the center. With the simple addition of petal shapes where the ovals join, the original pattern is completed (Diagram 5b). Now you have a basic pattern on which you can begin to build. Perhaps you'd like to add more petals to the flowers as I have started to do here.

(b)

Maybe you'll want to add a line to the top and bottom to create a band (I like the effect of a double line as a border, since it tends to frame the pattern more beautifully). By adding a simple design to the inside of the border (Diagram 5c), you create a much more elaborate pattern. As

(c)

(d)

(e)

with central motifs, filling in areas of solid color will create an altogether different effect (Diagram 5e). If you are interested in bolder, more geometric designs, this technique will be useful to you. My favorite motif for bracelet or border work is that of simple connecting spirals. (See Diagram 6.) This graceful design is easy to do and can be elaborated on in a variety of ways. If you look closely at the photographs in this book, you will find many variations on this classic pattern.

DIAGRAM 6

SPIRALS

Spirals can be a lot of fun when you get the hang of them. The most important thing to remember is to start at the center. Then take a moment to orient yourself and be clear about which direction you want the spiral to go (clockwise or counterclockwise) and how far you want the outermost edge to extend. Then you can decide whether you want the spiral tight and round or fluid and relaxed. If you want to do a spiral that is large, thin-lined, but dense, start at a center point and proceed slowly, focusing all your attention on running parallel to and equidistant from the edge of the previous rim.

THE DORA

Dora is a single or double-line enclosure about a central figure or two parallel lines and whatever motif is used between them. Thus, any two concentric circles with a pattern sandwiched between can be considered a dora. The use of the dora in Old Mehndi usually involves a rectangular shape or border used to outline the entire palm, creating an elaborate frame, often surrounding the central motif. I recommend that you begin with the central motif, if there is one. Otherwise, the central design can sometimes expand slightly beyond your expectations and cramp the negative space between itself and the dora.

Another traditional use of the dora is the *java*, or two straight lines, drawn to separate the fingers from the hand. This is a technique still seen quite frequently in mehndi, and it creates a lovely effect. Many times the motif used within the dores of the java will be repeated at each knuckle, creating a series of rings on each finger. These designs can be time-consuming due to the amount of finger work involved. One shortcut you can sometimes take is to use lines instead of full rings (see page 40). This is the appropriate technique if someone likes the pattern but wants the top of his or her hand to remain unpainted.

INSPIRATION

Once you begin doing mehndi, you begin to see in a different way. Suddenly patterns are everywhere. A new world unfolds within the old, and with it an insatiable appetite to see and discover more.

Seek inspiration from things that you find compelling. Slice a fruit or vegetable, and study the patterns of the seeds. Cucumbers, zucchini, apples, pears, and kiwis all form magnificent mandalas when you slice them

in rounds and hold them to the light. Notice the moldings, fences, gates, and windows in your neighborhood. Study the patterns of nature: the feathers of birds, light on water, the leaves and clouds. Study the lines of your own hand, the swirling prints of your fingers. There's so much to discover that's right there in front of you.

DON'T BE DISCOURAGED

Patterns are secrets, like puzzles. They can become so simple when you look at them in a different way. In that sense, they're like many things in life. You can try and try to force something to work, but as soon as you truly understand, it becomes effortless. Even the most complicated pat-tern can be created with ease. Otherwise tension, doubt, hesitation, and struggle will all be seen and felt in the work. Fluidity and grace are the result of knowing where the difficulty lies.

My advice is to apply the real energy to solving the riddle. . . .

Henna Gatherings

Part of what distinguishes henna painting from so many other art forms is that it is a social as well as personal and artistic experience. People gather to do henna for a myriad of reasons, ranging from the trivial to the profound. Henna parties can be an art form in and of themselves. Traditional gatherings in Africa and the Middle East are often several-day events with music, food, and dance. Whatever the celebration, the use of henna helps to create a special and memorable occasion.

Traditional Gatherings

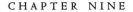

THE BRIDAL SHOWER
(THE HENNA OR MEHNDI *RAT*)

Matrimonial gatherings are the quintessential henna experience, combining all of the elements that make mehndi unique. A wedding is a time when people come together to witness and celebrate a rite of passage and to acknowledge the power that commitment has to transform lives. It can be a moving personal experience, as well as a communal one.

In traditional Jewish Yemenite weddings, the Henna ceremony, referred

to as the Henna, or *hinne,* is considered the height of the celebration, much the way a wedding reception is viewed in the West.

Parents of the bride are expected to throw a party in which friends and family and often an entire village or community gather to celebrate. It is a happy occasion (*simcha*) with much music and laughter and dancing, as well as food and drink for all. In this ceremony, the bride is elaborately dressed in clothing that weighs so much that she can hardly move. A processional referred to as the *zaffeh* takes place, in which the henna is presented to the bride. Women emerge with trays of flowers, candles, and henna on their heads and dance this way before the bride. The henna is then placed before the bride in powdered form. Water is added, and the henna is kneaded into a paste. After more dancing and singing, members of the family and close friends approach the bride to kiss and to bless her while spreading some henna in her palms. Gifts of money will be given by some. This is called *oseem hinne,* or doing the henna. As in most cultures, music and dance play an important role in the entire ceremony.

In India, the henna ceremony in the Hindu wedding is referred to as *Mehndi Rat.* During this ceremony, it is the women who gather to paint the bride. (It is said that the henna designs cover the bride's palm, just as her friends and family cover every inch of space on the floor around her.) In this playful and poignant ceremony, all the women will be painted with henna, sing, and tease the bride. They provide entertainment and support to calm her nerves and keep her spirits high.

OTHER TRADITIONAL FUNCTIONS

For centuries, henna has been used for private and public celebrations, including births, birthdays, naming ceremonies, circumcisions, and bar mitzvahs, as well as other religious feasts and ceremonies. It is said that in

Morocco, women anywhere will make henna painting the pretext for a small party.

Although there are some who associate henna rituals with the subjugation and oppression of women, the henna party is a female ritual, one that brings women together to talk, celebrate, and share.

THE *HAMAM* (Moslem Bathhouse)

Purification rites are an integral part of Islamic practice, and staining the skin with henna is an ablutional ritual. The belief is that mud or paint applied to the body carries away all evil and negative influences when washed from the skin.

In *Harem: The World Behind the Veil,* Alev Croutier writes:

> For Harem women, deprived of so many freedoms, the hamam became an all-consuming passion, and a most luxurious pastime. The bathing ritual took several hours, often lasting into the evening . . . the bath provided a chance to go out into the world. For some, the pilgrimage afforded sufficient freedom to arrange clandestine meetings. For all, the public baths were a center for gossip and a wellspring of invented scandal. They were women's private clubs.

Learning about the *hamam* helped me to understand more about Harem life and the nature of the role henna played in female society. In *Harem: The World Behind the Veil,* Alev Croutier gives detailed descriptions of how "women ladled perfume water over one another and hennaed their hair, hands and feet." They would lounge for hours at a time, eating sherbets and fruits, sipping lemonade, and smoking *chibuks,* or pipes. They would remove the hair from their bodies with a paste made of

lemon and sugar, and lie about, naked or partially clothed, discussing the day's events. Croutier adds that "on special occasions like weddings, floral designs made from henna were stamped on their bodies."

For women who lived their lives behind a veil, the hamam provided an opposite universe—one of contact, intimacy, and acceptance. The contrast between life within and life outside the hamam is difficult to fathom, the restrictions of one world being as unfamiliar to Westerners as the freedom and intimacies of the other. Here women could take comfort in each other's presence and find the freedom they were denied in the society of men.

MOROCCAN HENNA PARTIES

There's nothing as wonderful and magical as a Moroccan henna party, even if it's just an adaptation of a traditional gathering, which involves only women. The food, the music, the fragrances and flavors, and the ambiance are all part of an exciting, exotic, and transporting experience.

From the culture of the hamam comes the spirit of the Moroccan henna party. These events, sometimes three days long, are the most enigmatic and compelling henna gatherings that I know. In some cases they involve the practice of a kind of magic that bears an uncanny resemblance to voodoo. The pinnacle of this three-day-long celebration is reached when the woman who has thrown the party falls into a trance-like state and begins a convulsive gyrating dance, at which time the spirit of a *jinni* is thought to occupy her body.

Henna celebrations in Morocco are not just the province of women. The henna ceremony for the groom takes place just before the wedding. In the evening, his mother brings him a bowl of henna, four candles, an egg, and a bottle of water as a blessing. The egg is then ceremoniously broken and mixed into the henna with water. After his hands are smeared

with the paste, the candles are lit and placed within the bowl. Attendants then dance before the groom, with the bowl of candles balanced upon their heads until it drops to the ground and is shattered.

Henna Gatherings Today

FOR CLOSE FRIENDS AND FAMILY

Some people scoff at the recent popularity of ancient practices like yoga and meditation. But as technology speeds up, it becomes harder and harder for us to slow down. We are all searching for ways to unwind and put the pressures of the day behind us.

These days, gyms, spas, and workshops are often crowded and expensive, and getting to them can be exhausting. Doing mehndi requires a stillness and contact that can relieve tension and be great fun at the same time. Having a henna party can turn your own home into a healing sanctuary for your friends and family. In the book *Home Spa,* author Manine Rose Golden makes terrific suggestions that complement the practice of henna painting, providing recipes for natural scrubs, rubs, manicures, pedicures, body wraps, and even a mask to heal tired hands. There is a chapter called "Spa Parties," which includes a section on bridal showers. Not everyone will feel comfortable handing their guests towels at the door, but the idea of gathering with good friends to relax, rejuvenate, and visit seems very appealing.

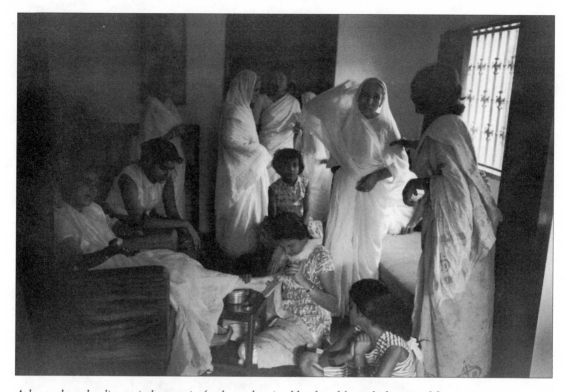

A key to the mehendi party is the necessity for the newly painted hands and feet to be kept immobile. The party thus envelops the painted bride, with attendant friends and family to render the most basic bodily services and to provide entertaining songs through the long hours during which the henna sets. ...the songs, in both form and content, articulate the underlying issues of the ritualized body and of the power struggles between husband and wife, wife-takers and wife-givers.

—PHYLLIS GORFAIN, "WEDDING SONG. . ."

TRANSFORMATION

No matter how few or how many guests there are, henna parties are memorable, intimate, joyful, and full of creative energy.

Mehndi seems to have a transforming effect on a group of people, young and old alike. As the evening gets under way, many distinct personalities become visible in the different patterns and designs—flowers,

stars, spirals, moons, vines, and snowflakes. A little girl requests a strawberry on her hand. Another wants a ladybug on her toe. A businessman has his ear painted while another man asks for an African symbol on his upper arm. Henna parties become an elaborate show-and-tell, with each emerging design sending waves of excitement through the room. This joyful activity breaks down barriers and creates a common and shared experience among all its participants.

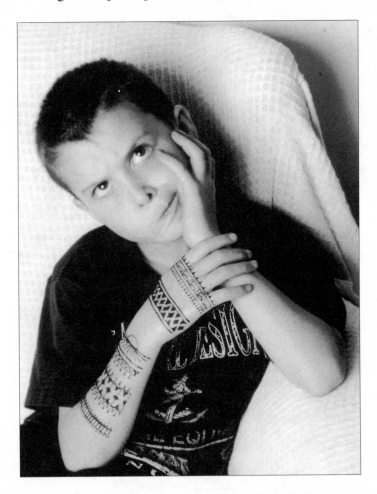

Henna has long been used as a way of keeping children out of mischief, since they must keep their hands still and touch nothing while the henna dries.

Henna for Each Other

A LONG TRADITION OF LOVE

Mehndi is a symbol of romantic love, deeply associated with the love between husband and wife. Through this medium, a woman is able to convey her feelings for her husband and pray for his well-being.

In our culture, the ring is used to signify marriage, and it is the only symbol worn beyond the wedding day to indicate the marital status of an individual. In India, a more noticeable transformation occurs as married women will wear a *bindi* (a mark at the center of the forehead) and henna in addition to many items of jewelry and ornamentation.

It's important to point out that the gift of a wedding ring in our culture is given in love and inspired by emotion. In India, bride and groom are often strangers. By the time they fall in love, they may have been married for quite some time. There is a lovely bit of conversation in the *Art of Rajasthan* between two women, one from Europe and one from India. When asked how she can marry a man she does not know, the woman from India responds by saying that whereas love in the West often ends in wedlock, in the East it *begins* with the consummation of marriage and continues to flourish and grow.

So you see, the celebration of emotion comes much later, and henna

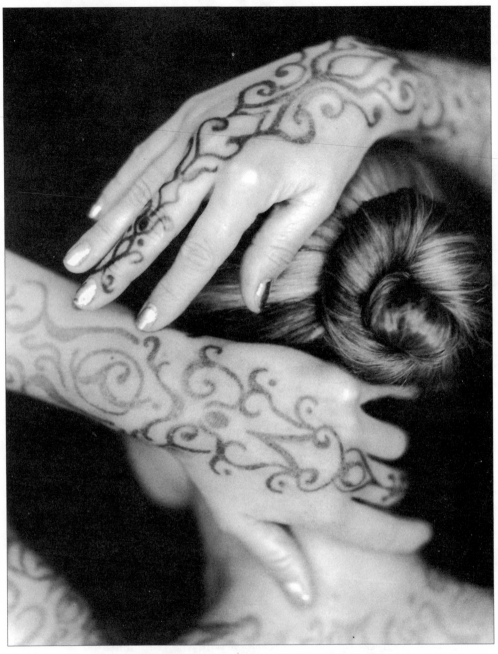

Even today, mehendi continues to cast a magic spell with its erotic appeal.

—CHAKRESH JAIN,

FROM "THE LURE OF MEHENDI"

provides the perfect vehicle by which a woman may proclaim her passion for her husband. There on her hand is the evidence of her love.

THE JOINING OF HANDS

In traditional wedding ceremonies in both the Moslem and Hindu faiths, the face of the bride often remained veiled, and only her hands and feet were visible to her future husband. Although generally women are no longer required to cover their faces, in many cases the bride and groom have never laid eyes on each other, and this is the groom's first glimpse of the woman who will be his wife. Every inch of the "bridal body" is transformed and glorified by adornment, covered with cloth, jewelry, or henna designs.

In Hindu tradition, a hand joining ceremony known as *hathleva* celebrates the first physical union of bride and groom with the blessing of henna between their palms:

It is a custom among the Hindus that at the time of the marriage the bride-groom and the bride observe *Sepata Padi* by going around the fire seven times. Before observing this ceremony and at the time of *gatha bandhan* (the act of uniting the bride and groom together), the boy holds the palm of the girl in his own hand with his palm up. This ceremony is called *hathaleva jurai* (coupling of hands). At the time of this unification a ball of mehndi paste is placed in the palm of the groom. Over this mehndi-held palm is placed the hand of the bride upside down and then joined. In this process the palm of the bride gets tinted red and this is considered auspicious by her friends and relatives.

It is generally believed that the deeper the tint of mehndi the happier will be their married life. The girl will enjoy unaccountable and

continued love of her husband throughout her life. It is therefore that Mehndi is described as *premras rāćani* which means the 'love-essence' which is always red. And the Mehndi saturated with such a love will naturally be supreme, pleasurable and deep in color and will tint the hands and feet gracefully.

—JOGENDRA SAKSENA

A favorite wedding custom, popular in many different cultures, is the tradition of hiding the initials of the groom in the mehndi design and then asking him to find them on the wedding night. (Mind you, in lan-

The paintings produced by the hand of the woman are intended to be scrutinized by the eye of the man.
—KATHERINE YOUNG,
FROM "WEDDING SONG…"

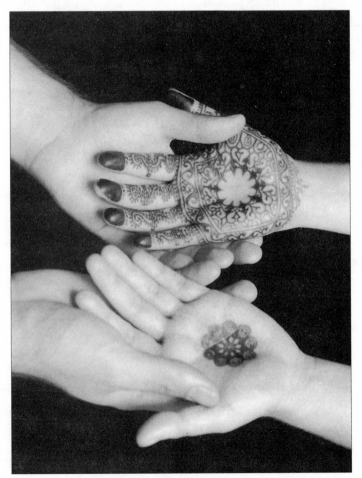

guages like Arabic and Hindi this is a lot harder than it would be in English.) If he does not find them, it is said that the wife will be the dominant one in the relationship; if he does, it is thought to be the reverse.

The issue of dominance and submission is of great significance in countries where the roles of men and women differ greatly from those in our own country. With its sexual and cultural implications, this dynamic plays itself out in bridal rituals such as the Mehndi Rat or the Henna. In *The Journal of American Folklore,* Phyllis Gorfain writes:

> The bride's submissiveness is thus visibly marked on her hands and feet—both instruments and symbols of her most basic personal powers, mobility, and the ability to alter her world. Aestheticized and eroticized by a clothing of henna, her stained hands and feet serve as testimony to her husband's care *of* her, as written on her body.

Many things are whispered about the mehndi of a bride. I have heard it said that the more intricate and elaborate the henna designs, the better schooled she is in the ways of love, because during the long hours necessary to do such work, she is simultaneously instructed in matters of the flesh. Although this is probably said in jest, it may have its roots in legitimate practice, though subjects such as these would never be discussed outright.

There are many superstitions and sayings surrounding the nuptial henna. As playful as many of these rituals are, there's a sensuality smoldering beneath the surface, lifting smokelike in each gesture and glance.

EROTICISM

Mehndi is associated with the sexual awakening of woman. From the monogamous and arranged marriages of Hindu and Sephardic tradition to

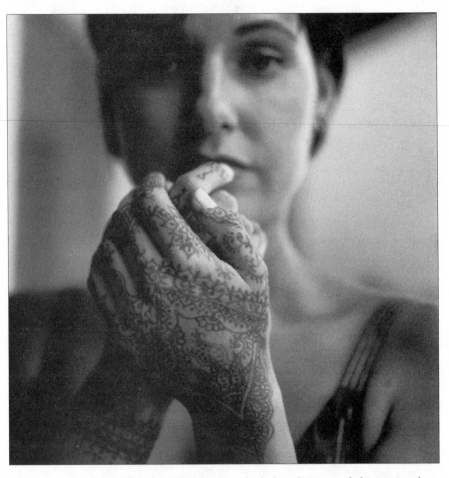

They at once absorb and deflect the gaze of the man, who finds in them, not only his imagery of women but also a reflection of himself, a way to find himself, secrete himself, to insert himself into the woman: his initial entwined in her inscription.

—KATHERINE YOUNG,
FROM "WEDDING SONG..."

the harems of Turkey or Persia, henna has been used for centuries as a sexual initiation rite. It announces the flowering of womanhood and the transformation of the virgin into an erotic being. It is immortalized in the folklore of India as a substance possessing the power to arouse the deepest longings in a woman. In *Art of Rajasthan,* Jogendra Saksena writes:

[It is said that] Mehndi decorations on a woman's palms charge her emotions to a state of frenzy. Then, she gets transformed into a different being. In those moments of ecstasy, if there is any need be, she would ride a horse and go galloping for two hundred miles in one breath. Because then, nothing would stop her from going out to meet her husband. . . . in moments of romantic ecstasy a woman would go to any extent to meet her desired end.

Mehndi is an art that communicates a woman's true feelings for her husband. Elaborate and intricate designs carry an erotic message. They speak of a woman's desire and love. Perhaps this is why men attribute magical properties to the substance itself. Henna is referred to as something of a love potion. In poetry, legend, and song, men tell of its power to incite passion and desire. In *Art of Rajasthan*, one legend compares "the ichor of Mehndi with the rapture of an intoxicated elephant":

Mendi ko mad joban-gand se bahai.

When an elephant becomes intoxicated and gets into a rapturous passion, mada starts flowing from his grandasthal (temple). Similarly, when a young woman decorates her palm with beautiful Mehndi designs, she gets intoxicated by the richness of the colour, grace and tenderness of the lines and the loveliness which the design imparts to her person. At that time she feels as if her whole youth has been filled with something which is unearthly and in that ecstasy she gets lost in her ownself, craving for her loved one's company.

In India, the fulfillment of earthly desire is referred to as *bhoga*, and erotic pleasure, or *kama*, is part of this pursuit. Elaborate ornamentation and adornment of the physical form is believed to heighten the couple's

kama and is one of the many ways a woman expresses her desire for her husband. In his book *Traditional Jewelry of India,* Oppi Untracht writes:

Women in Indian art and in life pursue adornment as a form of devotion to men, and with a fervency that parallels religious conviction. Only when they can no longer perform this role, as in widowhood or old age, do women abandon [this] by custom. While youth, fertility, and men exist, women in India follow a terrestrial theology in which [adornment] plays a significant role in achieving male and female union.

Romanticized, idealized, and eroticized, henna designs are thought to cast a spell on men and women alike. The effect that these designs have on a man is as much the stuff of legend as their effect on women. After all, each design is a visual manifestation of the passion and longing that his wife feels for him.

The love poems of India are filled with images of mehndi; passionate remembrances of patterns that, like the hands that bore them, have long since vanished in time.

THE BELOVED

The henna has sprouted a pair of leaves,
The love juice of henna is a lovely tint . . .
Oh lady, who has painted your hands?
The live juice of henna is a lovely tint . . .
Oh lady, put your hands on my heart,
The love juice of henna is a lovely tint . . .

—MEHNDI SONG OF MEWAR

Mehndi is a sensual experience that is more than visual. A man is bewitched not only by the graceful gestures of a woman's hands and the

She:

> *While the king rests on his bed,*
> *my perfume gives off its*
> * fragrance.*
> *My lover is like a bag of myrrh*
> *lying between my breasts.*
> *My beloved is like a cluster of*
> * henna*
> *plucked from the vineyards of*
> * Ein Gedi.*

He:

> *You are beautiful, my love.*
> *You are beautiful.*
> *Your eyes are doves.*
> > *—THE SONG OF SONGS,*
> > *FROM "FIRST LOVE STORIES"*

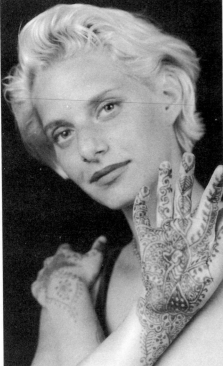

elaborate designs that adorn them, but also by the strong, musky scent of the dye upon the skin. Of travels in Tunisia, Barbara Barber writes: "But it was the men we knew who told us the real appeal of henna—its erotic effect on men. Henna has a very earthy smell that lasts as long as the stain does."

Legend has it that even the fragrance of the henna plant has an irresistible allure, said to draw forth both men and snakes when it blossoms in May and June.

THE LOVE POTION

Filigreed arabesques, swirling through space, closing it off, reconstituting themselves, extending new tendrils, minutely fenestrated, curled, branched, and rooted, the henna designs tease the eye to explore, curtail its explorations, reopen them, recapture them. They are at once representations and reflections.

—KATHERINE YOUNG, "WEDDING SONG..."

Being a substance with such intense associations and irresistible charm, mehndi is the subject of spells and superstitions. Even men have been known to use henna to conjure the protective powers of a woman's love.

In India, a Rajput warrior would attach a small pouch of henna to the scabbard of his sword so that he could rub some henna into his palm before battle. This would remind him of the ceremony, where he took his bride's hand for the first time.

Many of the symbols and designs painted in henna are done with the intention of protecting or enhancing a romantic relationship.

A common motif among women in Morocco is the image of an eye inside a heart. Usually drawn on the center of the palm, this pattern is meant to protect one's love from, among other things, the covetous glance of another.

Intimacy and the Imagination

Walking into any stationery store or card shop, one sees evidence of the many ways we use images to send messages to loved ones. It is a common part of our tradition of celebration. There are cards to honor birthdays, anniversaries, graduations, weddings, or religious ceremonies; cards to apologize or say thank you; to express love, regret, or hope.

You don't have to be an artist to create your own message. Henna offers so many possibilities, and there is no right or wrong way to use it. If you decide to put a secret message on your skin or your beloved's, there is no better way than your own.

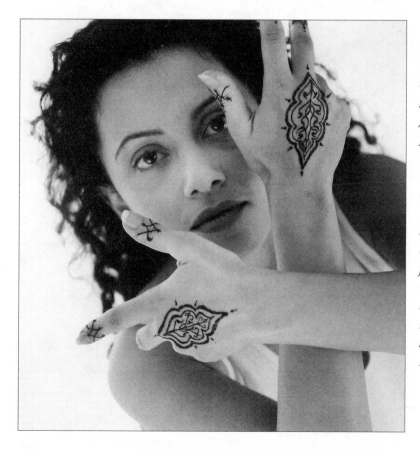

Dance, like poetry, celebrates the erotic nature of henna painting. In much of the dance in Africa and Asia, the beauty and grace of a woman's hands and feet will often be accentuated by jewelry and henna designs. In the Guedra, a ritual dance of love common among the people of North Africa, bracelets of silver and intricate henna designs are meant to focus the man's eye on the sensual movements of the fingers and hands, as a kneeling woman unveils herself within a circle of others. She will dance to the rhythm of their hands and voices until falling into a trance.

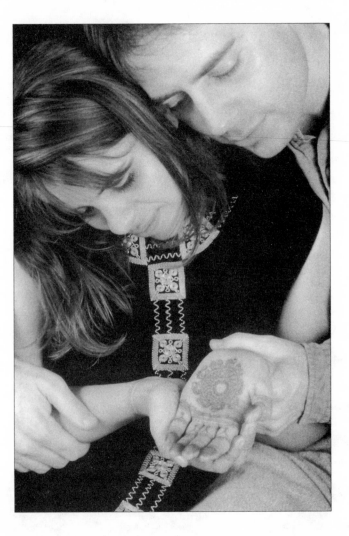

INTIMATE ENCOUNTERS

The practice of mehndi has for centuries been greatly influenced by religious convention, and yet at the heart of its function is the celebration of sexual union and marital love. You are not violating anyone's history by creating a history of your own. Let your lack of familiarity with this medium inspire you to create new ways of enjoying it. Be adventurous! Let henna be one more way to celebrate the person you love.

Here are a few suggestions for ways you and your partner can enjoy henna together:

Write a love letter on the skin.

Put a secret message in a favorite spot, and let your partner find it.

Prepare a bottle of henna paste for each of you, and paint each other. (If you want to be really daring, don't let the other see what you've done until you unwrap the designs in the morning.)

Give each other an anniversary to remember, and paint each other by candlelight.

Create patterns, phrases, or designs that complete themselves on your partner's body. (One fun way to do this is to use a ribbon or string to tie your hands together, tracing the lines with your own patterns or words.)

Give yourselves a pedicure, and paint each other's feet. Do it in winter when no one else will see.

Create designs for each other, and let them be your secret code.

Take your partner on a treasure hunt, and write the clues on your body.

Treat yourself and your partner to a day at home. Give yourselves the luxury of a full day alone, during which you can take long baths, give each other a massage, and cook a wonderful meal. This is the perfect way to experience mehndi. Paint each other in a special spot before watching a movie or going to bed.

Most of all, have fun! Henna can be your secret, and no one needs to know what you do with it. Give your partner and yourself the privacy that you need to play. If you've forgotten how, maybe mehndi can help you remember.

To the Artist

Contact is the essence of mehndi—an inner and outer contact. A contact between one's actions and beliefs, and a contact between people. The compassion and respect that you feel for your fellow beings has its voice in this aspect of the medium.

When two hands join, they form a bridge between two worlds. The joining of hands for any significant length of time has associations of familiarity, love, and affection. Even the most aloof personality can be transformed by this experience. It's hard to be distant when you're in physical contact with another living being.

One woman I worked with told me that I was the second person she had allowed to touch her in many years. She was a lovely person, and I consider it a privilege to have worked with her. I think the meeting was important to both of us.

You can sense a lot about a person by touching them. Some essence of their being communicates itself through contact alone. In most cases, the person you work with will really surprise you; that is, if you are open and willing to let go of your preconceptions. Your notion of who they are can be your greatest obstacle.

As a henna artist, you are holding open the door to another world. You are the guide, though the journey may take you where you've never

been. It is *your* attitude that will determine this person's experience of the medium. Know that the person you are working with will pick up on whatever you put out. If you are not able to put your subject at ease—if you are not welcoming, the quality of the work will suffer.

As well as asking what a person wants, you may want to tell them what it is you see. Often the lines of the hands will dictate a particular pattern, and you must try to describe what it is you imagine.

Design books are a Western phenomenon. The art of mehndi evolved through direct experience and practice, and each woman took care to develop her own style and technique. It can be a big mistake to let people choose their designs from a book. Copying a pattern from paper onto a hand is often difficult, frustrating work, lacks the fluidity and grace of real mehndi, and it may not allow you to do what you do best. Besides, it interferes with one's ability to react sensitively and to remain open and present. Use design books to get a basic feel for what someone likes, if you use them at all.

Rarely will anyone want just a pretty pattern once they realize how much more the art of mehndi can offer. Take the time. Help them to know this. By working devotedly with an individual to make visible their often surprisingly personal and often prayerful message, you are in a privileged position. You are made partner in a personal, sometimes spiritual, quest. In some small way, both of your lives may be changed.

HEALING

Is the art of henna healing? It's hard to say. Today, perhaps any form of beautification that is natural and good for the body may be considered healing. What's important is that henna can help women to reconnect

with their bodies in a positive way. It is also an art form friendly to the environment, and an increase in its popularity will only mean that more of these lovely plants will be grown and harvested.

Jogendra Saksena felt strongly that mehndi had the potential to "drive away the coldness of the machine age." He recognized it as a simple, natural activity that brings people together. In all the cultures where henna painting is practiced, it spreads joy, good feeling, and a spirit of togetherness. I believe that by helping to cherish and preserve this wonderful tradition, we are allowing it to help us in ways we do not yet fully understand.

Many people use mehndi to celebrate recovery, and personal symbols of healing are among the most moving and memorable patterns I've painted. People who have suffered from illness or injury have a hard-earned respect for the gift of the physical body—a respect that we who are well often lack. Because mehndi is a plant known for its medicinal properties, and because it is a nonintrusive body art used for centuries to enhance the beauty of the human form, it is a perfect medium for those who are healing.

Some people I've worked with have suffered injuries related to the hands, such as Carpal Tunnel Syndrome. Others struggled with cancer, while some used mehndi to celebrate sobriety. One woman in particular stands out in my mind. She approached me at an outdoor event on Martha's Vineyard and asked if I could paint on her ankle a lightning bolt piercing a heart. I was perplexed by the request until she explained that she had a defibrillator implanted in her body in order to send an electric shock to her heart if it were to stop, which it had on several occasions. The heart and the lightening bolt were the insignia of the company that made the device that was and is responsible for saving her life.

THE WHITE HEART

Mehndi, like any art, involves challenging one's self in the deepest way. Doing this work should never feel tedious or boring. In *Arts and Crafts of Morocco,* James Jereb writes, "There is a term used by the Berbers and the Arabs 'Blanc Coeur' (The White Heart) which signifies the amount of love and labor they put into their work of creation to which all artists can relate."

I am right-handed. When I did the elaborate pattern for the cover of this book, I first painted on my left hand using my right. After many hours of work, I was not satisfied with the proportions and knew that I wanted to do it again. The shoot was less than a week away and I had no time to find a model. So, I decided to try painting my right hand with my left. It took three hours longer than the other hand, but the result is the image on the cover of this book. Through my work with mehndi, I have discovered that many of my preconceptions about what I couldn't do were only the result of never having tried.

WHAT IS SACRED

Often I find that newcomers to mehndi will question their right to participate in the practice due to the religious nature of the art. They will ask if they are "stepping on anyone's toes," or "offending" the Hindus, Moslems, or Jews. They see themselves as outsiders, somehow unworthy of involvement in a tradition that isn't their own.

I understand this way of thinking, though I do not share it. Art is a universal language. It offers all of us a way of better knowing ourselves and each other.

Religion can be a way of perceiving our similarities instead of our dif-

ferences. There is a tendency for people to try to lay claim to the sacred by fixing it in space and time. But what is sacred is active and alive. It is we who invest an object with meaning, and the relationship between reverence and form is as personal as it is universal.

In *Dharma Art,* Chögyam Trungpa writes eloquently about the nature of the sacred in art:

> A work of art is created because there is basic sacredness, independent of the artist's particular religious faith or trust. The sacredness is the heaven aspect, which creates an umbrella, so to speak, that becomes very powerful and very *real.* At that point, human dignity is more important than the particular religion or discipline a person came from. . . . Sacredness from that point of view is the discovery of goodness, which is independent of personal, social, or physical restrictions.

It is a point of great significance to me that I have never felt the slightest bit of animosity from any of the people I have interviewed for this project. Each person, whether an artist from Morocco, a cab driver from Pakistan, a store owner from Egypt, a mother from Yemen, or a businessman from Kenya, has been helpful, generous, and enthusiastic about having a bit of his or her own heritage gain a little more recognition and attention. I find that my awareness of this one small aspect of so many rich cultures has allowed me to better understand the wealth of human experience that is all around me in a city like New York.

The most beautiful thing we can experience is the mysterious. It is the source of all true art and science.

—ALBERT EINSTEIN

A FINAL WORD

Mehndi is about listening. It is a way of getting to know someone. It is a way of learning about many different ways of life, and it is a way of hearing your own voice. Each person who asks to be hennaed holds out a hand to you. Notice.

If you are working joyfully and exploring the true potential of the medium, you are doing the work of a healer as well as an artist. You are using touch to effect changes, the least of which is a design in henna upon the skin.

I am a great believer in the power of intention. I am also of the mind that each encounter between two people holds a hidden meaning that unfolds at its own pace, in its own time. Henna provides the opportunity for a coming together; it is not the reason. The reason is the journey, and she is the veiled woman, shrouded in mystery, who enchants and beckons.

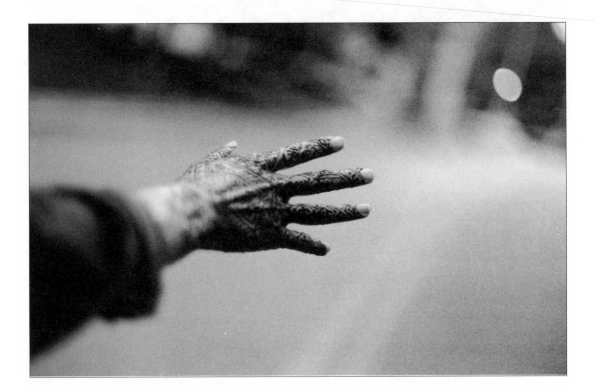

Resource Guide

SOURCES FOR HENNA (POWDER, CONES, AND KITS)

Color Trends
5129 Ballard Avenue NW
Seattle, Washington 98107
(206) 789-1065
Color Trends sells henna from India, Africa, and the Middle East. They have also assembled an exquisite mehndi kit for special occasions, as well as a range of simple kits, with all the essential tools and ingredients necessary to practice this art at any level of experience. The henna is sifted through a 120-millimeter sieve, and is ready to use. A delightful way to sample henna painting from sources all over the world: retail and wholesale available. Write for a complete listing of kits and prices.

If you are going to buy henna from a store, I recommend the following products (*all of the products listed here need to be sifted*):

Reshma Henna
Manufactured by Jawa Exports
Product of India

Shelly Mehndi Powder
Kaveri Enterprises
Product of India

Sada Bahar Dulhan Mehndi (Red)
Made in Pakistan

I find the following brands to be adequate:

Afshan Mehndi Henna Powder
Product of Pakistan
Packed by: Ahmed Food International

Badshan Henna (Mehendi) Powder
Jhaven Industries

Rainbow Henna (Persian Sherry)
Rainbow Research Corp.
Bohemia, NY
(Do not confuse this with Rainbow-Henna Mehendi, Prepared and packed by Shah Gabharubhal Uttamchand & Co.)

Kiran Henna
Product of Pakistan
Imported by Shere International, CA

Mumtaz—Al-Aroosa Superior Quality Henna
Harumal Gangaram & Co.
Product of India

Red Henna Powder (*this is a finely sifted product*)
Kremer Pigments Inc.
New York City
(212) 219-2394

I do not recommend the following products:

Egyptian Henna
A.I.I. Clubman
Los Angeles, CA

Black Bulhan Mehndi
Made in Pakistan

Henna (Black) To Adorn the 'EVE'
Product of India
Exporters: American Dry Fruits Ltd.

Zarga—Best Quality Henna A-1 (Black)
Product of Pakistan

Dulhan Mehndi, Deluxe Henna Powder
(Black)
Product of Bombay

Ceremonial Body Art
Temptu Mehendi
(This product is red paint and does not contain henna)
Ground and Packed by Tag Cosmetics & Toiletries Ltd.

A-1 Heena (black)—Mumtaz Heena Powder
Product of India

TO PURCHASE A HENNA PLANT:

Companion Plants
7247 Coolville Ridge Road
Athens, Ohio 45701
(614) 592-4643
You must ask for *Lawsonia inermis.* They sell a small plant about twelve inches tall for six dollars. (Make sure to ask them to check the plant for parasites or insects before sending).

FOR SUPPLIERS OF FRESH HENNA PASTE:

Ziba Beauty Center
18500 S. Pioneer Blvd.
Suite 203–204
Artesia, CA 90701
(562) 402-5131/Fax (562) 402-2139
Ziba is an Indian beauty salon specializing in traditional practices like mehndi and threading. Sumita Batra is an expert in the field, continuing the tradition her mother began when opening the business sixteen years ago. Gracious and enthusiastic, these ladies at

Ziba sell everything from handmade bindis to fresh henna paste (and you can be sure that the quality is good). The cost of overnight delivery is probably higher than the price of a single cone, but this is a wonderful option for those who are not interested in making henna themselves and just want to order some cones for a party or gathering.

SOURCES FOR OTHER INGREDIENTS

Color Trends
5129 Ballard Avenue NW
Seattle, Washington 98107
(206) 789-1065
Wholesale and retail suppliers. The Mehndi Project has worked with Color Trends to provide a mixture of all of the dry ingredients of our brew, combined in proper proportions. This company, acknowledged by the United Nations for its environmental integrity, is famous for its natural dyes, and is the only place I know to find such hard-to-get ingredients as dried pomegranate.

Sahadi Importing Co. Inc.
187 Atlantic Avenue
Brooklyn, NY 11201
(718) 624-4550
Started in 1895, this family run business has been on Atlantic Avenue for fifty years. They are the best source for herbs, coffees, and dried goods in bulk.

Little India Stores
128 East 28th Street
NY, NY 10016
(212) 683-1691

Kalustyan's
K. Kalustyan's Orient Expert Trading Corporation
123 Lexington Avenue
NY, NY 10016
(212) 685-8458
They sell tamarind and mustard oil and have a great spice selection. Wholesale and retail suppliers. They do mail order service worldwide.

Penny's Herb Company & General Store
97 1/2 East 7th Street
NY, NY 10009
(212) 614-0716
Sells black walnut hulls powdered, as well as fenugreek seeds and a variety of roots, barks, flowers, and leaves. Also sells eucalyptus oil at six dollars an ounce. They do mail order service worldwide.

Avraham Sand
Tiferet International
210 Crest Drive
Eugene, OR 97405
(503) 344-7019
Tiferet manufactures essential oils and provides a pamphlet with some interesting and helpful information.

Sources for Tools, Accessories, and Supplies:

Imports from Marrekesh
Contact Mohamed Elmaarouf
(212) 591-2188
Once host to The Mehndi Project at his store, The Gates of Marrekesh, Mohamed Elmaarouf is the definitive resource for anything you may want from Morocco, ranging from tours to textiles to live music. Specializing in Moroccan interior decorations, Mohamed is a wholesale and retail supplier of henna-painted lamps, sifters, and drums, as well as tapestries, trays, and pillows of all shapes and sizes. Ask for information on henna-related items or party rental supplies.

Jacquard
Rupert, Gibbon & Spider, Inc.
(800) 442-0455
(707) 433-9577
Makes the Jacquard bottle. The staff may be able to provide information about the retail supplier nearest you.

Ceramic Supply of New York and New Jersey
1-800-723-7264
They sell the Talisman sieve. (Be sure to request a fineness of at least 120 holes per square inch for the mesh.)

The Evolution Store
120 Spring Street
NY, NY 10012
(212) 343-1114
Evolution is a store that sells fossils, bones, shells, insects, and butterflies of many shapes and sizes. It also is one of the few places in New York where you can find porcupine quills. It will do mail order, with a minimum of a twenty-dollar purchase. Since porcupine quills cost only three dollars, you may want to see if the store's website is set up in order to make additional purchases.

Color Trends
5129 Ballard Avenue NW
Seattle, Washington 98107
(206) 789-1065
Carries wonderful agave exfoliating washcloths and scrubbers.

Rashid Sales Company
Arabic Music Catalog
1-800-843-9401

Artemis Imports
P.O. Box 68
Pacific Grove, CA 93950
(408) 373-6762
This is a belly-dance supply company that has been in business for nineteen years. The catalog is full of wonderful products from Morocco and the Middle East, including costumes, veils, music, books, instruments, costume jewelry (for the ankles, belly, hands, and head as well as the usual) cosmetics (including henna), and all sorts of other exotic paraphernalia, all for extremely reasonable prices. I recommend ordering the catalog to anyone interested in exploring the exotic in a lighthearted, inexpensive way.

Henna Artists:

The Mehndi Project
(212) 969-8820

BIBLIOGRAPHY

Argüelles, José and Miriam. *Mandala*. Boston and London: Shambhala, 1995.

Barthes, Roland and Annette Lavers (tr.). *Mythologies*. New York: Hill and Wang, 1972.

Bhanawat, Dr. Mahendra. *Menhadi Rang Rachi (Folkloric study of colourful Myrtle)*. Udaipur: Bhartiya Lok-kala, 1976.

Burton, Richard (tr.). *Kama Sutra*. New York: Risus Press, 1936.

Burton, Sir Richard F. (tr.). *The Kama Sutra of Vatsayana*, foreword by Santha Rama Rau. New York: Arkana/Penguin Books, 1962.

Croutier, Alev Lytle. *Harem: The World Behind The Veil*. New York: Abbeville Press, 1989.

Fontana, David. *The Secret Language of Symbols*. San Francisco: Chronicle, 1994.

Frankl, Viktor E. *The Will To Meanings, Foundations and Applications of Logotherapy*. New York: Meridian, 1970.

Golden, Manine Rosa. *Home Spa: Recipes and Techniques to Restore and Refresh*. New York—London—Paris: Abbeville Press, 1997.

Goodwin, Jan. *Price of Honor: Muslim Women Lift the Veil of Silence on the Islamic World*. Boston—New York—Toronto—London: Little, Brown, 1994.

Grabar, Oleg. *The Mediation of Ornament*. Princeton: Princeton University Press, 1992.

Handa, O.C. *Pahari Folk Art*. D. B. Taraporevala & Sons, 1975.

Huntley, H. E. *The Divine Proportion: A Study in Mathematical Beauty*. New York: Dover Publications, Inc., 1970.

Jereb, James F. *Arts and Crafts of Morocco*. San Francisco: Chronicle Books, 1995.

Jung, Carl G., ed. *Man and His Symbols*. New York: Dell, 1964.

Kanafani, Aida Sami. *Aesthetics and Ritual in the United Arab Emirates*. Beirut: The American University of Beirut, 1983.

Macrac, Janet. *Therapeutic Touch: A Practical Guide*. New York: Alfred A. Knopf, 1996.

Maisel, Eric. *A Life in the Arts*. New York: A Jeremy P. Tarcher/Putnam Book, 1992.

Manniche, Lise. *An Ancient Egyptian Herbal*. London: British Museum Publications, Ltd., 1989.

Nourse, Alan E. *The Body*. New York: Time-Life Books, 1964.

Phoenix and Arabeth. *Henna (Mehndi) Body Art Handbook: Complete How-To Guide*, 1997.

Prakash, K. *Paisleys and Other Textile Designs from India*. New York: Dover Publications, Inc., 1994.

Saksena, Jogendra. *Art of Rajasthan: Henna and Floor Decorations*. Delhi: Sundeep Prakashan.

Searight, Susan. *The Use and Function of Tattooing on Moroccan Women.* New Haven: HRAFlex Books, MW1-001 Ethnography Series, 1984.

Shalaka, Narvekai. *Art of Mehandi.* Bombay: Navneet Publications Ltd., 1996.

Shankar, Ann and Jenny Housego. *Bridal Durries of India.* Ahmedabad: Mapin Publishing Pvt. Ltd., 1997.

Sinha, Indra (tr.). *The Love Teachings of Kama Sutra.* New York: Marlowe & Company, 1997.

Stewart, Ian. *Nature's Numbers: The Unreal Reality of Mathematics.* New York: Basic Books, 1995.

Trungpa, Chögyam. *Dharma Art.* Boston and London: Shambhala, 1996.

Untracht, Oppi. *Traditional Jewelry of India.* New York: Harry N. Abrams, Inc., 1997.

Wolkstein, Diane. *The First Love Stories.* New York: HarperCollins, 1991.

EXHIBIT CATALOGS

Aditi: The Living Arts of India. Washington, D.C.: Smithsonian Institution Press, 1985.

Reinisch, Helmut and Wilfried Stanzer. *Berber, Tribal Carpets and Weavings from Morocco.* The R. Hersberger Collection, 1991.

ARTICLES

Cohen, Rona I. "A Jewish Yemenite Henna Ceremony and Its Dances." *Journal of the Association of Graduate Dance Ethnologists.* Spring 1981, Vol. 5, pp. 29–36.

Gorfain, Phyllis; Deborah Kapchan; and Katherine Young. "Wedding Song: Henna Art among Pakistani Women in New York City." *Journal of American Folklore.* Winter 1996, Vol. 109, no. 143.

Jain, Chakresh. "The Lure of Mehendi." *Arts of Asia.*

Messina, Maria. "Henna Party: An Orange-red Cosmetic Raises Moroccan Women's Spirits." *Natural History* 1988, Vol. 97 (9).

Saksena, Jogendra. "Henna for Happiness."

Siegel Barber, Barbara. "Tunisian Images: Of Henna and Weddings." *Arabesque.* Sept.–Oct. 1987, Vol. 15, No. 3.

Elwin, V. "The Decoration of the Body." *Art and Industry* 4, 1947.

"Life in India Behind the Veil." *National Geographic,* Aug. 1977, p. 280.

"Manners and Customs of Mankind." Vol. 1, London: Amalgamated Press, circa 1930, pp. 553–4.

Encyclopedia Britannica, Vol. 2, p. 356. "First published in 1768 by a society of gentlemen in Scotland, William Benton, Publisher."

VIDEOTAPE AND BOOKLET

Slyomovics, Susan and Amanda Dargan (Directors). *Wedding Song: Henna Art Among Pakistani Women in New York City.* 1990 (sponsored by Queens Council on the Arts, (718) 291-1100).

PHOTOGRAPHIC CREDITS

The author and publisher wish to thank the many talented photographers who contributed time, energy, and vision to this book. Their work is listed here in order of appearance. We would also like to thank Magnum and Art Archives for providing us with additional material.

Black & White Photographs

ARTIST	PAGE NUMBER	PHOTOGRAPHER	MODEL
Loretta Roome	vi	Tracey Eller	Loretta Roome
Jaimila El Alaoui	xiv	Tracey Eller	Jenny Liu
Artist Unknown	7	Marilyn Silverstone-Magnum	
Loretta Roome	11	Jill Waterman	Margaret Bodell
Loretta Roome	13	Gordon Lang Kelly	Mañuela Amzallag
Loretta Roome	21	Tracey Eller	Eric Feinstein
Loretta Roome	23	Tracey Eller	Dina Emerson
Loretta Roome	24	Huggie Foote	Lisa
Stephanie Rudloe	27	Tracey Eller	Randolyn Zinn
Jamila El Alaoui	29	Tracey Eller	Jenny Liu
Loretta Roome	39	Tracey Eller	Loretta Roome
Loretta Roome	40	Tracey Eller	Sandra Roger
Stephanie Rudloe	44	Jill Waterman	Julianne Swartz
Judy Ann Olson	47	Robert Tardio	Judy Ann Olson
Leigh Brown	50	Tracey Eller	Serena Jost
Loretta Roome	52	Theo Coloumbe	Dina Emerson
Loretta Roome	54	Gordon Lang Kelly	Mañuela Amzallag
Loretta Roome	55	Karl Steinbrenner	Audrey Davenport
Stephanie Rudloe	57	Robert Tardio	Rabeah Ghaffari
Jamila El Alaoui	61	Tracey Eller	Alana
Loretta Roome	64	Jill Waterman	Barbara Pollack
Loretta Roome	65	Jill Waterman	Madelena Montiel
	68	Tracey Eller	
Loretta Roome	72	Gordon Lang Kelly	Mañuela Amzallag
Loretta Roome	75	Jill Waterman	Margaret Bodell
Loretta Roome	83	Audrey Davenport	Tracey Eller
Leigh Brown	94	Jill Waterman	Jeanna Hong

159

INDEX